SCULPTING
IN
WOOD

SCULPTING IN WOOD

Peter Clothier

A&C Black

First published in Great Britain in 2007
A & C Black Publishers Limited
38 Soho Square
London W1D 3HB
www.acblack.com

ISBN 13: 978-07136-7490-3

Copyright © Peter Clothier 2007

CIP Catalogue records for this book are available from the British Library and the US Library of Congress.

Book design by Penny & Tony Mills
Cover design by Sutchinda Rangsi Thompson
Cover images (front): *A Hare Swimming Through a Sea of Barley* by Peter Clothier and images from the shark project.
Cover image (back): *The Swimmer* by Stefanie Rocknack.

Printed and bound in China

This book is produced using paper that is made from wood grown in managed, sustainable forests. It is natural, renewable and recyclable. The logging and manufacturing processes conform to the environmental regulations of the country of origin.

Acknowledgements

Every craftsman learns their skills from a variety of people. I was incredibly lucky to have been shown so much by two craftsmen in particular. The late mastercarver Gino Masero and Bernard Baverstock of Beckley in Sussex both gave me enormous help and guidance and I will always be indebited to them. To the many craftsmen who also gave advice so willingly I give my thanks.

Many thanks must go also to the team at A&C Blacks particularly Linda Lambert and my editor Alison Stace.

CONTENTS

For my Darling Tabitha

INTRODUCTION

The aim of this book is to show anyone from eight to eighty how to design and make wood sculpture, with very few tools. The unique way that each individual relates to their world, and their ability to express that experience, has the potential to give them tremendous satisfaction and fulfilment. But people often worry that because they can't draw or don't know the finer points of anatomy, they will be unable to make a piece of sculpture. By using the 'model first' method of working, students of wood sculpture can, using their ideas, bypass the drawing stage if preferred, and work out their chosen form. Then, by using simply-made templates, begin sculpting straight away. The sculptures made by the Inuit people, Henry Moore and Barlach to mention a few, although often not anatomically accurate, have a tremendous spirit and presence. This book is designed to encourage anyone who would like to make a sculpture, whatever their artistic ability, to explore the wonderful possibilities of working with wood, giving their own special vision to the finished object.

The Zen masters say that everything is contained in the first lesson. With that idea in mind, this book has been written starting with the simplest of projects, using very few tools and straightforward woodworking techniques. Once you have learnt the basic skills needed for working with timber by using hand tools, then, if appropriate, the effective and safe use of power tools becomes a more realistic prospect. This book will not try to deal with the huge and growing subject of woodworking power tools; if you decide to equip your workshop with power tools I strongly recommend that you are trained adequately in their safe use. If time is not a critical factor in your sculpting, you may find that the use of hand tools is both relaxing and a pleasant source of exercise. I have tried to keep the use of machinery to a minimum and all the projects can be made using only hand tools. The last project has an alternative option and can also be made using power tools.

I have arranged this book in such a way that, through a series of projects and the gradual introduction of tools, you can build your skills and confidence as you work. Newcomers to wood sculpture are often discouraged from starting because of the prospect of maintaining the sharpness of their tools. The first three projects need tools that have replaceable or throw-away blades, and so no tool sharpening is needed, and I have deliberately not used knives because of the obvious danger. There are also chapters on sanding and finishing your final sculpture. I hope that this book will encourage inexperienced tool users to try wood sculpture.

The early projects are deliberately simplified forms to allow you to learn the sculpting processes and skills that will enable you to develop your ability and have the confidence to attempt more demanding work, and in time launch yourself into your own original work. I wish you many hours of pleasure and fulfilment.

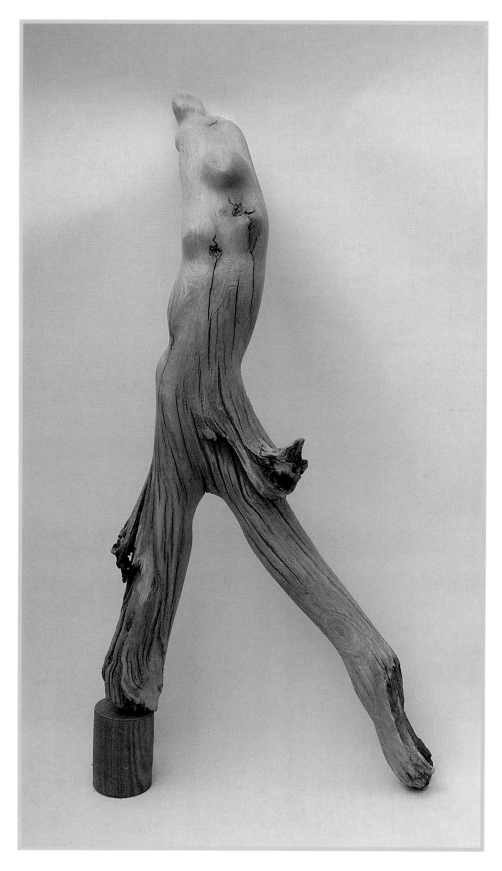

The dancer sanded with 100g paper ready for final sanding and a Danish oil finish.

GETTING STARTED

Making sculpture is rather like going on a journey. The way an individual approaches making sculpture will, to a great extent, say a great deal about them. Some will enjoy detailed work while others may prefer to just give a broad impression of their chosen subject. If we use the analogy of travel when considering our approach to sculpture, then some people love to just get up and go while others plan their journey in great detail. Planning a journey or sculpture can be an exciting part of the whole experience, deciding on the various options and alternatives can be part of the enjoyment. Ultimately, it is up to you which route you take, but if you're reading this book you may be, to some extent, in need of a guide for your first few adventures into wood sculpture.

IDEAS

So, the sculptural journey begins with the idea that you want to make an object, using wood. There may be many starting points to this adventure; possibly you have an interesting piece of wood you would like to work with, or have an idea of a shape or form that you would like to explore or maybe it's just that you would like to try working with wood.

Some sculptors are intuitive and can visualise a finished piece and make it without hesitation, others have an innate sense of play and experimentation and just follow the wood and their instincts to produce wonderful work. Complicated and specific pieces often call for drawings, sketches or detailed models; scale or full-size models may be required if large and expensive commissions are undertaken. Whatever your approach to sculpture, the important thing is for you to find the best way to express your ideas; hopefully this book will help you on the way.

RESEARCH

Project One – The Dancer (see opposite), requires very few tools. If you are keen to get started on a piece of sculpture, all you need to do is find a piece of weathered, garden or even store bought wood, read the relevant parts in the chapters on tools and skills and then, by following the process on p. 67 create your own piece of work.

If this style of work is not to your taste and you would prefer a more structured approach to sculpture then Project Two – The Rabbit, may be a method of working that would suit you better. Either project is a good starting point for making a wood sculpture and getting used to using simple tools.

When we come to projects that require accuracy in terms of form, i.e. we want a rabbit to look like a rabbit or at least have the general impression of a rabbit, then more information about the subject would be helpful. Just as a journey begins with looking at brochures and reading travel guides, so with planning a wood sculpture we need to gather as much information as possible to be well informed about the proposed project. Resources such as photographs, drawings (your own or reproductions), taxidermy subjects and even sculpture by other artists are all extremely useful (although copying work by other sculptors may not be such a good idea as the result tends to lose the vitality of original work, but if it gives you as a beginner a starting point then go for it!).

Once you have gathered enough information, you then need to know how to apply this to the project. Drawing is a very important and useful skill and I would encourage any would-be sculptor to try to develop their skills in this area. The great value of drawing is not to create pictures, but to train the eye to observe form and detail, and to record this observation by making notes. Don't be afraid to write useful information on your sketch if it helps to remind you of any useful details and fixes the information in your memory; these notes can be remembered or referred to during the sculpting process. Probably the biggest problem when making drawings for sculpture is that a 2D medium is being used to express a 3D subject and although this is possible, it is difficult, even for a skilled draughtsman.

MODELS

Although even the finest sculptors from Michelangelo to Rodin and Henry Moore, were wonderful draughtsmen, they would often make a sketch model or maquette to help them visualise an idea before sculpting. A maquette is a sculptor's preliminary model usually made from clay, wax, plaster or plasticine. Michelangelo used red pigmented beeswax for his maquettes, Rodin, the master of clay modelling, naturally used terracotta clay as well as wax, and Henry Moore used clay, plaster and plasticine, quite often combining these materials with found objects such as lumps of flint and pieces of bone to create his amazing work.

When starting to plan a sculpture a clear idea of the

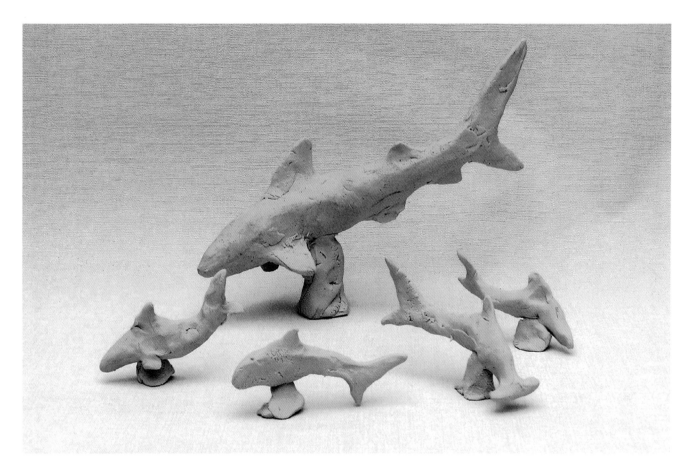

Thumb-sized sketch models and final working model for the shark project.

finished work may still not be resolved, and this is the great advantage of the 'making a model first' approach, using plastic materials such as modelling clay, plasticine, wax, etc. Sketch models can be made to establish the direction that the work may go in. I often make a series of thumb-sized sketch models just to get started and then select one or two and make a larger version of each to see if I am going in the right direction. I then use the best parts from each in the final model.

The advantage of making a model is that it can be adjusted to give feelings of movement or space. Modelling with plasticine or clay is relatively quick, compared with the slow and methodical process of sculpting, so it is possible to try out dozens of ideas quickly and easily. If you are stuck for ideas grab some plasticine and just experiment with it, and have fun! Plasticine is relatively clean and can be used anywhere in any spare moments, without the need to use special equipment.

MAKING THE MODEL OR MAQUETTE

If possible, make the model or maquette the same size that your final sculpture is intended to be. This will be a great help if you need to ensure that the finished piece will fit in a particular location, as the model can be placed there to check its suitability. It also makes the transfer of measurements from the model to the work much simpler during sculpting. The model-making process also allows you to explore your subject. Once the final form has been established the model can be used to make your templates. However, if making the model the same size as your sculpture is not appropriate, you can make the required final dimensions of the sculpture by adjusting the template size. (See p.21 for adjusting the size of your template).

Materials

The three most commonly used materials for making maquettes are plasticine, clay and wax. **Plasticine** is fairly inexpensive and easy to obtain; there are more sophisticated versions of modelling clays available (see suppliers p. 123) but for our purposes plasticine is perfectly adequate. It has the advantages of not being messy when being modelled and the final maquette can be handled without it being spoilt, which is very important both during template making and when it is being handled while taking measurements, throughout the sculpting process. Plasticine is firm at normal room temperature and is easily made more malleable by rolling it between your hands; if the temperature is cold it can be softened by warming with a hair dryer. Plasticine that is old and hard can sometimes be revived in a microwave oven (2 minutes maximum and beware it will be very hot). If your plasticine model tends to collapse, it can be made firm temporarily by cooling in the refrigerator for an hour or so. The surface of your plasticine model can be smoothed out using a paint brush and vaseline if needed.

There are two types of **clay** that may be used for making maquettes. **Terracotta clay** is very good to model with, allowing subtle modelling with good detail, but it does have the disadvantages that it is messy to handle and it must be kept moist or it will crack and possibly fall apart. You may need an armature to support it (see p.12). If you decide to keep it moist, it simply needs to be wrapped in clingfilm or a plastic bag. To improve its chances of survival when drying, try not to have the clay thicker than about 3–4cm (1¼ –1 ½in.) anywhere (if your maquette is quite large you can even take a teaspoon and hollow it out a little from the bottom where it is probably thickest), then allow it to dry out very slowly, away from direct heat. If the project is going

to take a long time and warrants the extra work, it may be a good plan to make a plaster cast of the clay model, which then will not need such careful handling and therefore will be much better for taking measurements from during the sculpting process. (See *The Sculptor's Bible* by John Plowman or *Mould Making* by Sasha Wardell for details on making plaster moulds.) **Self hardening clay** can be worked almost like normal clay and has the advantage that cracking is minimal (especially if it is allowed to dry slowly); when fully dry the model can be safely handled. It has another big advantage in that it can be coloured or given an appropriate finish e.g. painted or gilded. This can be very useful to show to a client and also for visualising how the proposed sculpture will look in its final position if it is 'site critical'.

Wax is another commonly used mouldable media available for model making. Modern modelling waxes are different from those used in the past. Beeswax melted and mixed with resin and pigment has now been superseded by microcrystalline wax. These modern waxes can be coloured and adjusted for ease of working (see manufacturer's directions). It takes a little more experience to work with this material than plasticine but the results are always interesting. Although the detail that can be achieved using dental tools and a small spirit lamp is incredibly fine, by the use of broader modelling methods wonderfully abstracted flowing shapes can be formed (although bear in mind that there is no point working out the fine details unless this is your final model).

THE MODELLING PROCESS

Using the resource material you have collected you can now begin making some thumb-sized models by squeezing some plasticine into simple shapes. Make several, modelling quickly, just like a simple sketch drawing. This will either confirm some existing ideas or help give a direction to your next larger model.

The next maquette can be two or three times the size of the thumb sketches. When ideas are really beginning to appeal to you, then make a full-sized model to use for your finished piece of work. Modelling is a very personal activity; this is about you and your perception of the world. The unique qualities of each individual are what make each piece of work so special.

The modelling tools illustrated opposite are those that I find most useful, particularly the wire loops and the small boxwood modelling tool.

As the models increase in size so may the possibility that they will become too heavy to support themselves, particularly upright figures and those with projecting arms and legs. To provide some support you can use an armature, which is basically a simple skeleton made of wire or square aluminium extrusions, specially designed for armatures (see suppliers on p.123 for wire stockists). However almost any wire that can be easily formed is perfectly suitable. I frequently make maquettes up to 22.5cm (9in.) tall which don't need an armature, although sometimes a strategically placed cocktail or barbeque stick may be needed to support a drooping arm or head.

Try to be accurate with the overall shape or form of your model but do not to get too involved with too much detail. One of the interesting things that happens as your wood sculpture progresses is that the differences between working with the soft mouldable material of your model and the harder, more resistant wood you are shaping will mean that you will have to make decisions on how to work with the wood, and change the way you respond to it. If your sketch model is made from plasticine further refining and resolving of detail can be worked out on the model, as the sculpture progresses, although obviously within the boundaries of the wood that is available. So the refinement of (for example) an eye or a nose can be effectively resolved by further modelling on the model, before attempting to finish the element concerned on the sculpture.

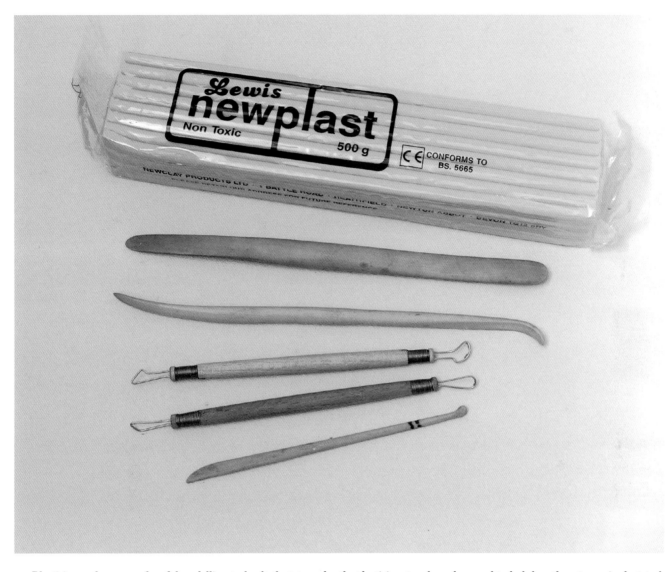

Plasticine and a range of useful modelling tools. At the top, under the plasticine, two large boxwood tools, below them two wire loop tools and at the bottom a small boxwood modelling tool.

The sketch model is about getting the overall shape and composition of your sculpture the way you want it. Do what feels right for you. Making the model or maquette is a huge part of the creative process; decisions made to the overall form at this stage cannot be changed; once the sculpture is roughed out (see p. 77–81) after which, the only changes that can be made are in detail and to the nature of the surface. Time spent getting the overall shape of the model correct is very well

repaid. Some sculptors may say that the spontaneity of making sculpture is lessened by the rehearsal of making a model, but I assure you that there will be lots of creative decisions to make throughout the sculpting process!

The size of models or maquette can vary. I find that when working from a model, both in the making of templates (see p. 75–7) and for taking measurements during sculpting that if it is the same size as the intended finished work, i.e. 1: 1 the

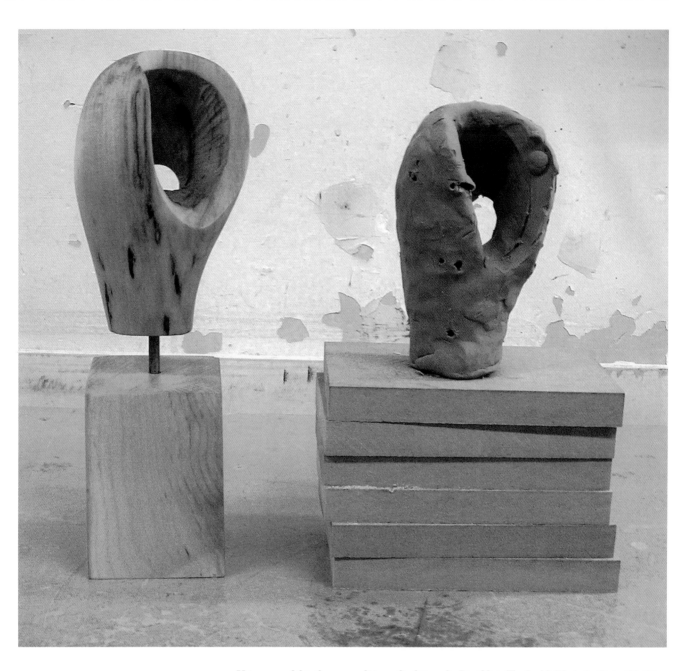

Using a model to form a sculpture. Sculpture by Dr. Chris Tredgold. Photo by Peter Clothier.

copying and transferring from model to sculpture is much easier. It also helps to ensure that the finished work will be appropriate in its intended final display position. For much larger pieces of work this is not always possible, and so then half and even quarter size maquettes should be made, as appropriate to the project. (See p.21 on adjusting sizes of sculpture in relation to the maquette).

HINTS ON MAQUETTE OR MODEL MAKING

Remember that once the model is made there will be occasions when it has to be moved. If you have made it on a wooden base then it will be easier to move it around, or place it on a 'lazy Susan' rotating base, so that by turning, it can easily be viewed from all sides.

If you make the model on a separate base and you need to use some kind of armature to support the model, it will be easier to fix the armature to a wooden base. Your thumb-nail and larger sketch models should give a good indication as to whether some sort of armature is going to be needed. You can try to make the model without one and if it sags just push a cocktail or barbecue stick into the sagging part and see if that gives enough support.

If that is not effective, or you feel that an armature will be necessary, then wire or thin aluminium rod can be moulded into the model to give the extra support needed.

When modelling try to just use your fingers, certainly during making the thumbnail sketches and the initial stages of later models. The use of modelling tools tends to encourage too much concentration on details which, although very important, are very much less significant than the broad shape of the form of the sculpture model.

Although warm plasticine is fairly easy to use, as it becomes cold it hardens and is not so easy to model. Make the model by applying small lumps, already warmed by rolling it between the fingers and moulding it into the form. Any big changes to the form can be made by cutting lumps off using a blunt knife. So by a process of adding and removing plasticine, followed by more detailed modelling we arrive at the finished maquette.

Rather than rush onto the next stage, try to put your model in a position in your home or workshop where you can look at it, and if possible turn it or walk around it so that you can see it from several different perspectives; a useful technique is to look at it reflected in a mirror. By standing back and looking at your model, you may well notice parts that would benefit from further modelling. Visually weak areas of the model can be identified if you photograph it from the main elevations; quite often a photograph will show up points that would be improved with further modelling. One of the most useful features of a model is that it allows you to twist and pull the form into various shapes, so you can explore the multitude of possible shapes for your final work. In this way, the final wood sculptures do not have to look wooden!

SCULPTING WITHOUT MAQUETTE MAKING

Sometimes in the press or at wood shows, you will see fine sculptures made by individuals who claim that they have never had a lesson – they just picked up a knife and carved. The problem for we ordinary mortals is that we often need help and advice with our sculpture or it is possible to waste a great deal of time and wood before making a piece of work that we feel is satisfactory. It is possible to launch into a sculpture and just work out the details as you carve, letting the nature of the wood guide your shaping. The dancer project is for those sculptors who like to go with the nature of the wood.

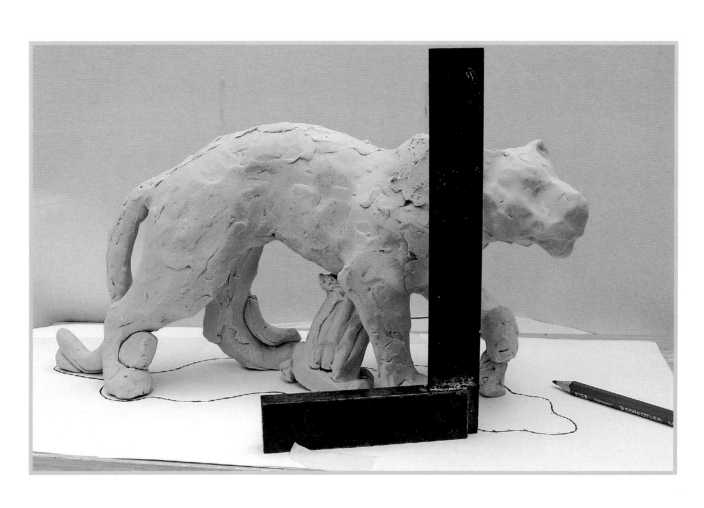

Try square in position for marking out template.

TEMPLATES

Once you have the model or maquette of your proposed sculpture and are completely satisfied with the overall form, then the next stage is to make the templates.

For our purposes, a template is an accurate drawing of the silhouette or profile of the maquette from a specific viewpoint, for example, the view from directly above an object is called the plan view, so the plan view of a boot is the outline of the sole. We can also view the maquette from the side giving the side elevation or from the front, showing the front elevation. Ideally the use of two templates, e.g. a plan and side elevation used in conjunction, allows the sculptor to identify and remove the unwanted wood from the original block, safely and quickly because the limits of the finished object are within the overall shapes marked by the outlines delineated by the two template profiles. Sometimes it is only possible to have one template. Removal of material from the waste side of the template shapes is called the **roughing out**.

It is easier to work from the model if it is exactly the same size as the intended sculpture. However, it is quite difficult, especially if you are an inexperienced model maker, to get the final size exactly correct. You may have already selected or even been given a piece of wood that is to be used for the sculpture, or the sculpture may have to be of a specific size because of its final use or position. For a variety of reasons, it is quite possible that the model you have made is not a perfect fit or size for the finished piece. Fortunately, this can be remedied. Once the templates are made, the size of the final sculpture can be adjusted to a perfect fit by the simple use of a photocopier to alter the size of the templates. If you don't have easy access to a photocopier, you can use the squaring up method of size adjustment (as published in *The Encyclopedia of Drawing Techniques* by Ian Simpson).

Squaring up

'Mark the original drawing (or a tracing) with a grid of squares, e.g. 2.5cm (1in.). On a clean sheet of paper mark another grid of squares that will give the required increase in size; e.g. if your original squares are 1in. (25mm) and you want to increase the image by 150% then the increased squares will be 3.8cm (1½in.). Transfer the image by using the points where the original drawing intersects its grid and marking them on the new grid. Using the original drawing as a guide, fill in the shapes between these points as you work to create the enlarged drawing.'

(From The Encyclopedia of Drawing Techniques,
by Ian Simpson)

You may find that when trying to fit a model to your chosen timber, the wood may not be quite the correct size! This problem can be solved by making an adjustment to the maquette, and then by making a new template (see p. 18). A simple sketch maquette will allow you to make templates to help ascertain if the wood to be used for the project is big enough in all dimensions.

MAKING A TEMPLATE

You will need:

1 Paper, big enough to allow a margin of not less than 2.5cm (1in.) larger than the final template. Use drawing grade paper for a more hardwearing final template.

2 A carpenter's or engineer's try square, with a blade long enough to reach any part projecting beyond the outline of the model (see p. 16).

3 An HB pencil with a long sharp point or a fine black fibre tip pen.

To make a plan template, i.e. the view from directly above the model, place the maquette on its base on the paper, stand the stock (wide edge) of the try square on the paper next to the model, the metal blade projecting perpendicularly upwards at a right angle, with the outer edge of the blade just touching the model wherever the shape projects (see p.19). At the point where the edge of the blade of the try square touches the model, follow the edge of the blade down to where it exactly meets the paper; at that point make a small mark. Repeat every 5mm (¼in.) all around the perimeter of the model so that finally you will have an irregular ring of dots spaced 5mm

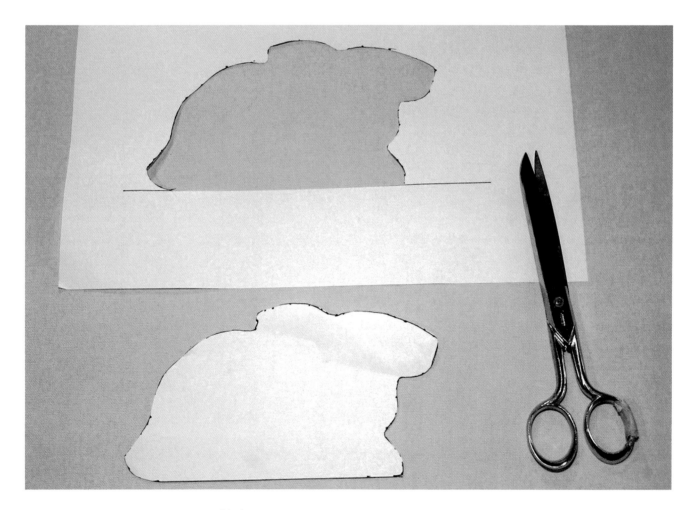

Rabbit templates. (Top) *negative template can be placed on sculpting block to assist in selecting position of sculpture.*
(Below) *positive template for use in conjunction with other templates.*

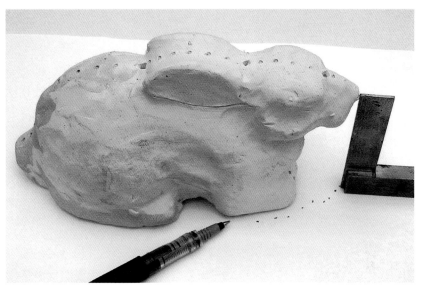

The plan view template in the process of being marked out using a try square and pen.

(¼in.) apart. Join the dots to give the extreme outline of the plan of the model (see p.18).

Cut out the template along the resulting line. If this process is done carefully and accurately you will then have the positive template and the original piece of paper with a negative shape that can be used as a window template. This negative or window template can be extremely useful as by placing it on the wood chosen for the sculpture and by looking though the aperture, you can decide on the positioning of the sculpture in the wood.

If the grain of the wood is to be a feature of the finished piece or if the need arises to avoid areas of your timber that contain knots or other blemishes, then by manipulating the negative template window, it is much easier to see how the sculpture will work with that particular piece of wood. This allows you to make the best use of your chosen piece of timber. The window method also allows you to determine the orientation of the timber, particularly when you need to gain the maximum strength of the final piece; by ensuring that the correct direction of the grain is selected, the strongest orientation is given, as far as possible. Placing the window template over the wood and trying various positions will enable you to decide which is the best final position for the templates.

Making templates for the plan or base elevation of a model is straightforward, but to make a side or front elevation template, more attention to detail is needed. In order to make a side elevation template, it is necessary to lay the maquette on its side, on the sheet of paper that will become the template. Again, it is important to make sure that the table or bench top is flat. Pack pads of plasticine (I am assuming that, certainly if this is your first project, you are using plasticine) to support the model so that it is parallel to the paper. While your model is in the normal standing position push a matchstick into the top of it so that it is absolutely perpendicular. It is very important to ensure that the flat base of the model is absolutely at a right angle (90 degrees) to the template paper. This must be checked with the try square, the back of its stock on the paper and the outside edge of the blade against the base of the maquette and the matchstick should be exactly parallel to the template paper.

Having set up the model so that the side is parallel to the paper and that the base is perfectly at right angles to the paper, proceed as before when making the base template, marking at the point where the corner of the square is in contact with the paper every 0.5cm (¼in.) around the shape. Once this has been

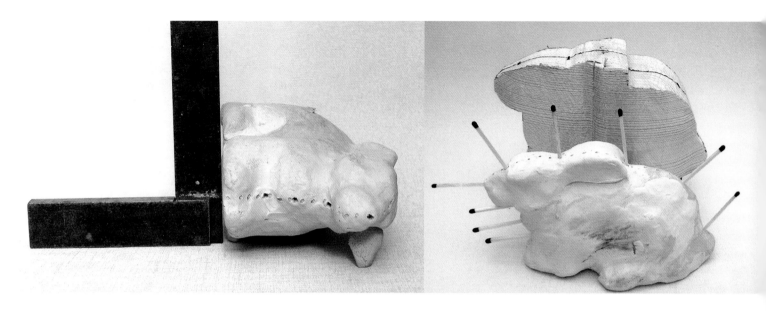

Using the try square to ensure that the model is exactly at right angles to the ground in order to make an accurate side elevation template.

Maquette showing use of matchsticks.

completed, join the dots and cut out the template (see image on p. 18).

When you are making templates for two adjacent elevations, the correct and accurate orientation of the model during template making, i.e. at right angles to one another, can be checked by pushing matchsticks perpendicularly into the upward facing elevation during the making of the first

template. When making the second template, by making sure that the matchsticks are at right angles with their original position, i.e. they are in a horizontal position, then the resulting templates will be exact representations of the profiles of the maquette at right angles to the original (see photo above). Another way to make sure that the right angle between side and front template elevations on models with a flat base is

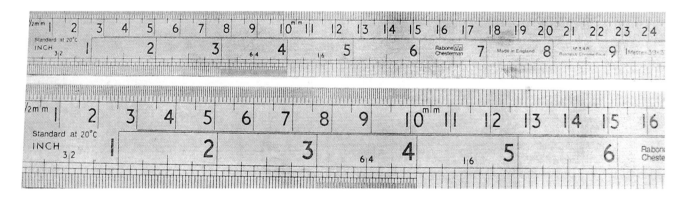

Scale rod showing correct size rule (on top) and photocopied version marked with new proportions (below), showing a 150% increase.

maintained, is to scratch a perpendicular line on the base during the making of the first template and then when the model is repositioned for making the second template check that the line is then in the horizontal position. When the two templates are applied to square cut timber, they will work in combination to give an accurate three-dimensional outline to guide at the roughing out stage, when the wood on the waste or outside of the template-marked areas is removed.

Remember that the shape of the base template is also the same shape as the top view, that the right-hand template is a mirror image of the left-hand template and finally that the front template is the same shape as the back template. Naturally, very great care must be taken in the orientation of the templates when they are applied to the wood, before marking around them.

HOW TO USE TEMPLATES

It is vital that templates are accurately lined up with one another, so that when roughing out (see p.74) is carried out the resulting form is not distorted or out of alignment. This is relatively simple to achieve for front and side elevation templates, if the base of the sculpture is flat, because the templates can be aligned according to the base line, either by fitting them against the base of the wood to be sculpted or by aligning the templates with a line squared (that is a line marked all the way around the wood indicating the base line of the sculpture).

A very important point to consider is how the piece will be held during sculpting. It may be that some spare wood can be left on the base of the sculpture so that you can hold it while you are working on it; this can then be removed after the sculpture is completed or retained as the base on the finished work. If the sculpture only just fits the wood, as in the rabbit project, then you can glue and/or screw a block of wood to the base, which can be removed when it is no longer needed.

Once the positions for the templates are correct, draw around the outsides using a felt tipped pen or pencil. If the waste wood is to be removed using a band saw, then template marking on two adjacent faces, e.g. plan view and side view of the model, is all that is required; if you are using hand tools (handsaws and rasps etc), then use the templates to mark all the faces of the wood so that when working, cutting can be done from all sides. I always keep any templates I make as a reference for other jobs and on the off chance that another similar sculpture is requested.

If your sculpture is not the same size as your original model and you changed the size of your final templates to fit your wood by using a photocopier the problem arises of transferring measurements from your model to your sculpture. When you are working with a model that is the same size as the finished sculpture measurements can be directly transferred. If your enlarged templates are, for instance, 130% bigger than the originals and therefore your model, then every measurement will have to be increased to 130% which involves a great deal of calculations. One simple way to overcome this problem is to make up a **scale rod.** When you alter the size of the original templates, say to 130%, while the copier is set at the new size setting; make a photocopy of a rule. Then return the copier to 100% and make a copy so that you have two images, one of a normal size rule and the other of the image of the rule at the new 130% scale. Glue the two different size copies of rules side by side on a strip of card or thin wood. To use the scale rod, take a measurement from the model, check the measurement on the normal rule, say 5 cm (2 in.) then go to the 130% version of the rule and reset your calliper to the same 5 cm (2 in.) measurement, which will give you the correctly adjusted measurement for your sculpture.

If making a model first is not appropriate sometimes then just copying a physical object is another way to get started, whether it is a banana, a book or a burger. It is quite feasible to make templates from many objects; if you decide to make a larger or smaller version of it, photocopy the templates to give the final size of sculpture you choose.

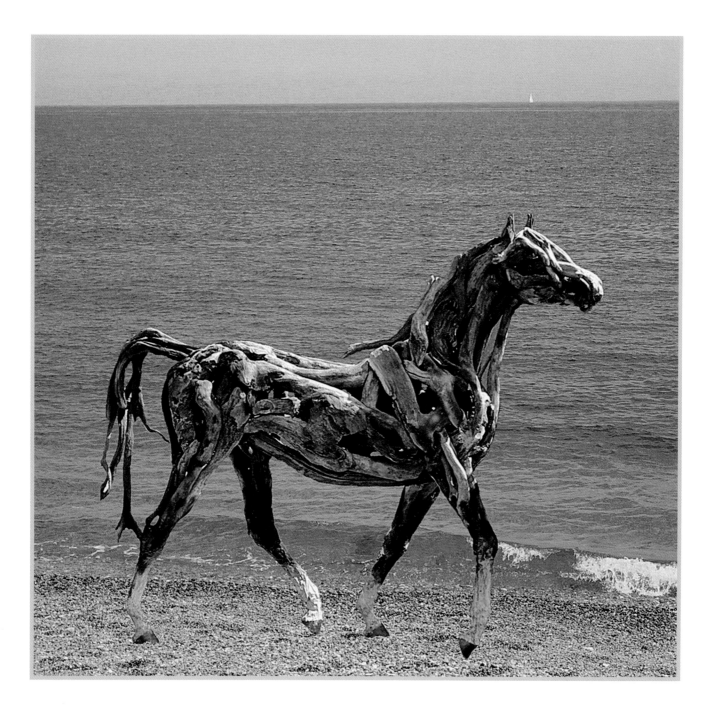

Apollo, *life-size driftwood horse by Heather Jansch. A galvanised or painted mild steel frame is used and covered with car filler which is then painted brown. The driftwood pieces are gradually attached to the framework to build up the piece, using stainless steel screws. As hardwoods are used, the final pieces are very heavy and have to be lifted by hoists and motorcycle lifts. In order to create the sculptures we use chisels, mallets, wire brushes, files and sand paper to acheive the textures, and we also use chainsaws, small electric saws and an angle grinder with a wood carving attachment.* Photo by Heather Jansch.

ABOUT WOOD

The terms wood sculpture and woodcarving are often used in interchangeable ways, however there are notable differences between the two ways of working. For the sculptor, the important qualities of the timber to be used for a piece of work are colour, nature of the grain and the ability to carry out certain finishing procedures that will emphasise the meaning of the piece. Woodcarvers will try to select a timber that will allow accurate cutting with chisels, the resulting cuts and marks being left as the final surface on a piece of work whereas often the sculptor will work in a broad way with little concern for fine detail. An indication of these different approaches to working is seen in the tools that are used. Woodcarvers work almost exclusively with a large range of chisels and in some cases special knives. Wood sculptors have an enormous range of tools available. Generally some chisels are used in the early stages, but because they will be creating a variety of forms and final surfaces, many other tools such as surforms, rasps and rifflers, and often the extensive use of abrasive techniques. Modern power tools, such as flexible drive tools, make it possible for the sculptor to work with almost any timber, particularly those which are very hard or soft and those that are impregnated with grit and other inclusions that would quickly blunt ordinary carving chisels. Do not worry too much about the wood you are going to use, as long as it is fairly dry and you can work it with the tools you have. Rather than repeat the lists of timbers that can be used (see p. 29), I would prefer to consider how to evaluate a piece of wood and the best way to use it. You do not need vast amounts of wood to make a wood sculpture, nor do you need to spend huge amounts of money on tools at the beginning.

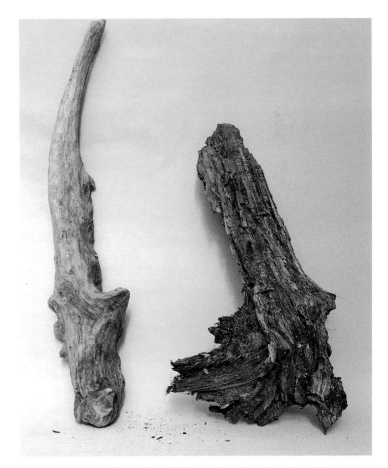

Examples of driftwood and weathered wood.

Wood that is suitable for carving can come from a variety of sources, including garden trees, weathered wood such as driftwood or wood found on the forest floor (often partly rotten), fire wood, recycled furniture, as well as the obvious sources such as timber merchants, builders' suppliers and mail order companies (see p. 123 for suppliers).

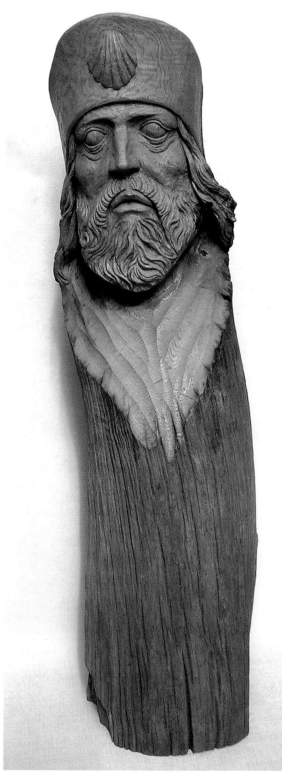

Variety of possible wood types; driftwood, weathered wood, garden wood and seasoned wood.
(Right) Pilgrim *by Peter Clothier. From weathered sweet chestnut.*
(Opposite) *Oak boards 'in stick' stacked in a wood yard.*

The timber that you obtain, depending on its source, will be in one of two conditions. Either dry or seasoned, and ready to work with immediately; or wet, unseasoned and green, which may require further processing and treatment before it can be used. Driftwood and weathered wood usually fall into the wet category, because although they usually do not contain any sap, they will need to be dried since they have usually been in a wet environment.

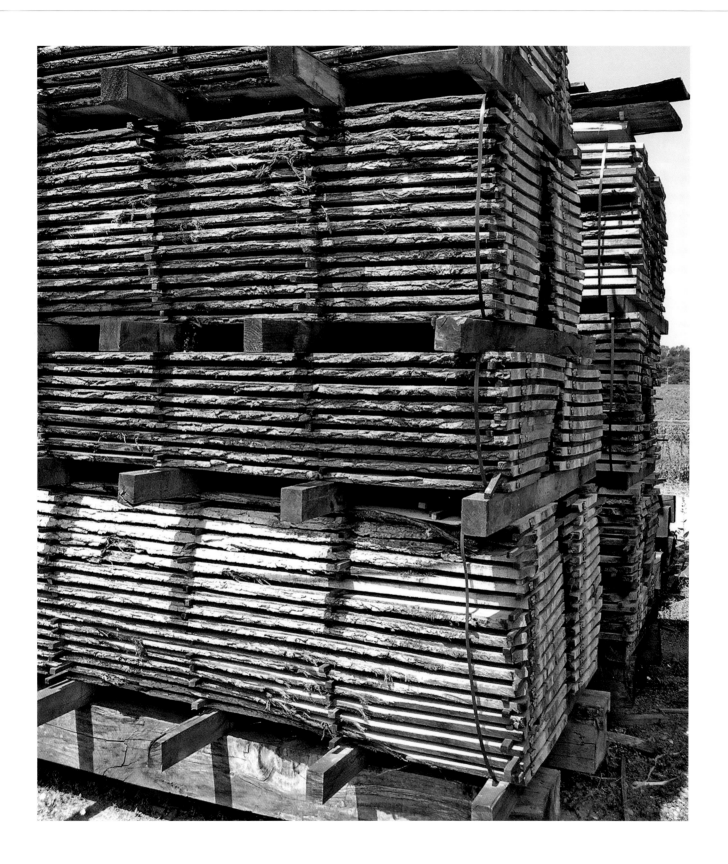

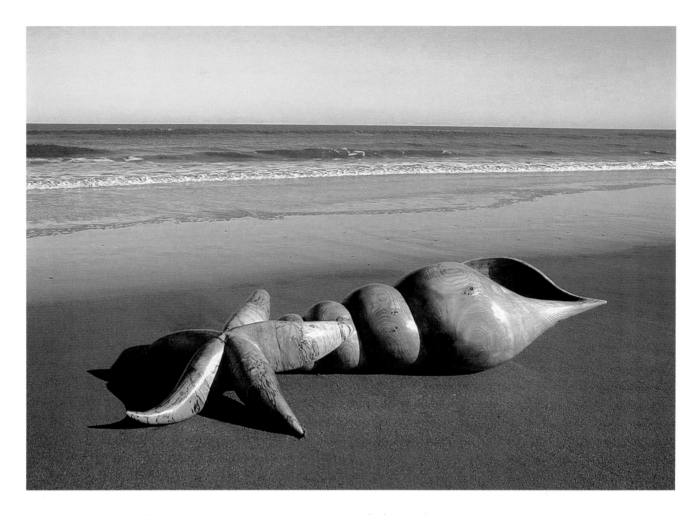

Shell and Starfish *by Mick Burns. The shell is approx: 1.21m (4ft) long. The timber used was European Larch (Larix Decidua), and was finished with three coats Danish oil and beeswax polish. The starfish is approx: 0.75m (2½ft). It was carved from spalted beech wood, also carved with a chainsaw and finished in the same way as the shell.*

There are advantages and disadvantages to working with both dry and green timbers. The great advantage that dry or seasoned timber has is that it is less likely to shrink, split or warp during use and in the finished pieces. It is also easier to machine, plane and saw, and it will glue effectively, allowing you to use larger blocks of timber for big projects. Seasoning or drying is usually carried out in a special drying kiln; the resulting 'kiln dried' timber is the usual timber available from builders' merchants and wood suppliers. If the timber is allowed to dry naturally, under cover in open sided sheds, then it is referred to as air dried.

The traditional way of air drying timber is to cut the log into boards and stack them with sticks (sawn timber laths about 20mm (¾in.) spaced at intervals in between each board. This allows air to circulate and the boards to dry. The boards are usually left to dry for one year for every 25mm (1in.) of thickness. So a 75mm (3in.) board would take three years to air season.

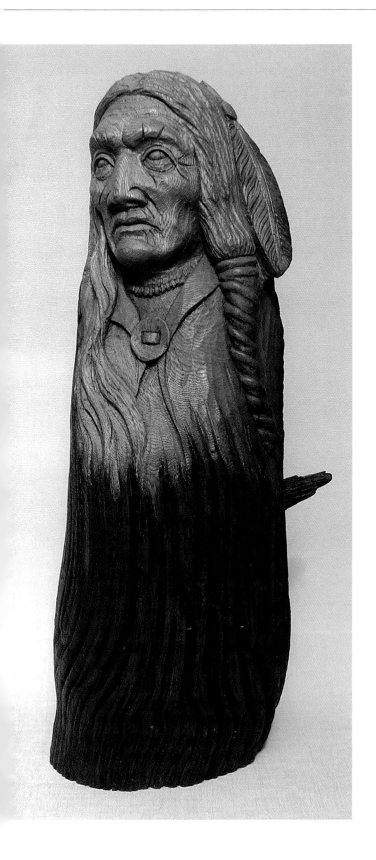

The disadvantages of seasoned timber are that only common timbers are easily available; the timber is generally cut into standard thicknesses and widths; and the wood will cost more because it has been subject to machining and other treatments.

Sawn seasoned timber is available in fairly limited thicknesses usually 25mm (1in.), 50mm (2in.), 75mm (3in.) and 100mm (4in.). It is possible to obtain sizes up to 150mm (6in.) but this is generally considered speciality-sized timber that is used by boat builders and other woodworking trades. Salvage yards and boat builders' yards can yield interesting off-cuts suitable for wood sculpture.

Green or unseasoned timber is generally cheaper, may even be free, and often is an unusual type of wood. It can be cut to various sizes, even large blocks, to suit your requirements. It may have interesting features and shapes that will inspire you. However, green wood often cracks as it dries out and this could spoil your work, but by preparing and cutting the wood in certain ways, splitting can often be reduced to an acceptable level. By being prepared to accept minor blemishes in the finished work, a very great range of useable woods become available. Always bear in mind that wood is a natural material and it will have characteristics that reflect its origins. It will have knots and occasional splits, the grain will be awkward at times but this is the nature of wood and will impart character to your finished piece. Having worked with it you will know and respect it. Making wood sculpture with found or weathered wood is, for me, incredibly satisfying.

First Nation *by Peter Clothier. Height: 35cm (14in.). Sculpted from sweet chestnut wood. Finished with Danish oil.*

Possible sources of wood for sculpture

- Timber yards
- Saw mills
- Boat yards
- Forest floor- permission from the owner may be needed
- Garden trees
- Tree surgeons
- Local builders often know of trees being pruned or removed
- Recycling; old furniture often yields very interesting timbers

Try your phone directories for local contacts. Woodworking periodicals always have advertisements for mail order suppliers for tools and timber. There is also a list of suppliers on p. 125.

Apart from the dancer, the projects in this book all use bought seasoned timber. I used pine, a soft wood that is commonly available. Pine is a predictable and stable material that is easy to sculpt while you learn the various techniques. Once you have made a few pieces it will be easier for you to make decisions about other woods and ways of working.

Timber is classified as either hardwood or softwood. Generally softwoods are produced from cone-bearing trees or conifers. Hard woods come from broad leaved trees, and strangely many are less hard than some so called softwoods! Pine, spruce and yew are softwoods, whereas apple, lime, Jelutong and balsa are all hardwoods.

So, how do you decide which wood to use for a certain piece of work? There is no exact answer, of course, but the first thing to learn about a given piece of wood is how does it cut? If it crumbles, can it be cut back to sound timber? Is it so hard that your tools will barely cut it and so make sculpting it difficult? Will you be able to shape the sort of detail that you wish to? The answers will only be apparent if you take a tool such as a chisel or rasp and try to work the wood. From the results you should be able to decide the appropriateness of the wood to the project in mind. This simple approach is by far the best way to learn about woods, once you have used a timber you will discover more about it than will be gleaned from dry and wordy descriptions!

For the novice wood carver the choice of timbers is overwhelming so I will suggest some timbers that should be reliable to work with (see opposite).

It is not always possible to identify wood you may come across, particularly driftwood and found forest timber but they are often wonderful sources for creative sculptures.

Although there are drying problems with green wood, it is probably the only source of timber available in sizes larger than 180mm (8in.) by 180mm (8in.) in section, other than glued blocks. When timber dries it loses water from the surface, and by losing water it loses volume or shrinks. The result can be a split in the timber surface or the wood may warp because of the stresses caused during drying. If wood is left with the heart in the centre of the block, then the stresses will almost certainly cause splitting along the direction of the grain, these splits may run into the centre of the log. However, if the timber is cut lengthways through the heart then the chances of splitting are reduced. The risk is reduced further still if the wood is quartered through the heart, because the wood can shrink and warp more easily, rather than splitting. After being sawn, stresses on the drying timber are reduced by ensuring that the drying is carried out as slowly as possible which allows the wood to 'move' without splitting. Drying can be slowed by keeping the green wood, when it is not being worked, in a paper sack, but avoid plastic sacks as they tend to trap moisture and cause fungus to grow on the surface of the wood. Keeping the wood out of the sun and drying winds is vital. Because green wood is free or at least inexpensive you can prepare more than one piece at a time, so if some pieces do split, the financial loss is very small.

A guide as to when a piece of wood is air dry is to weigh it, say once a month, and when the weight is the same for two months in a row, then it is safe to assume that the moisture level in the wood has stabilised. If you then take it indoors it will almost certainly lose more moisture. It is not necessary to have huge amounts of wood to make sculpture. A piece of wood the size of a loaf of bread will provide enough material for many hours of enjoyable sculpting!

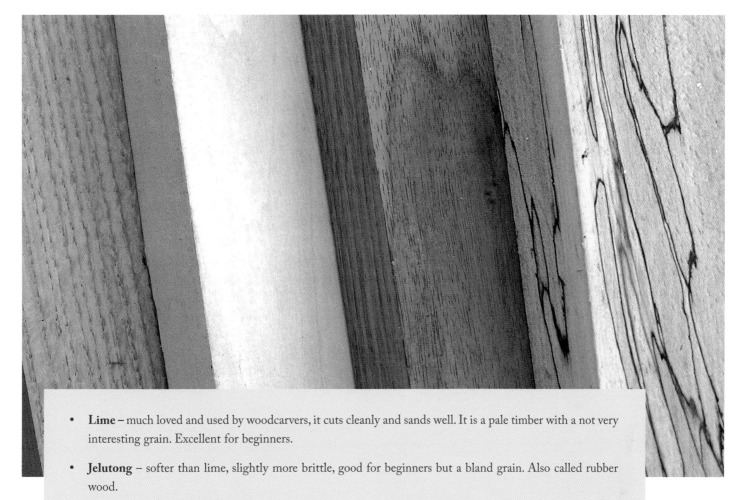

- **Lime** – much loved and used by woodcarvers, it cuts cleanly and sands well. It is a pale timber with a not very interesting grain. Excellent for beginners.

- **Jelutong** – softer than lime, slightly more brittle, good for beginners but a bland grain. Also called rubber wood.

- **Pine** – a soft wood with quite pronounced grain cuts easily and sands well. It has a pale colour that darkens to a warm honey colour quite soon after sculpting. This is the timber used for the rabbit, shark and tiger projects. Interesting effects can be created on the surface by wire brushing and sand blasting.

- **Walnut** – a beautiful timber that shapes and sands well. Capable of taking fine detail. May have paler sapwood which is susceptible to woodworm.

- **Oak** – although a hard timber it produces a superb surface and can have a wonderful colour and figure.

- **Cherry, maple, sycamore and beech** – all vary from pale to warm tones, are quite hard to work but will sand to a silky finish.

- **Yew** – although technically a softwood, this is a hard timber with warm brown heartwood and creamy pale sapwood. It does tend to have hairline cracks and is quite brittle, needing a light touch. The dust produced during sanding is an irritant and a dust mask is essential.

(Above) A selection of timbers suitable for sculpting. From left to right: oak, lime, walnut and spalted beech.

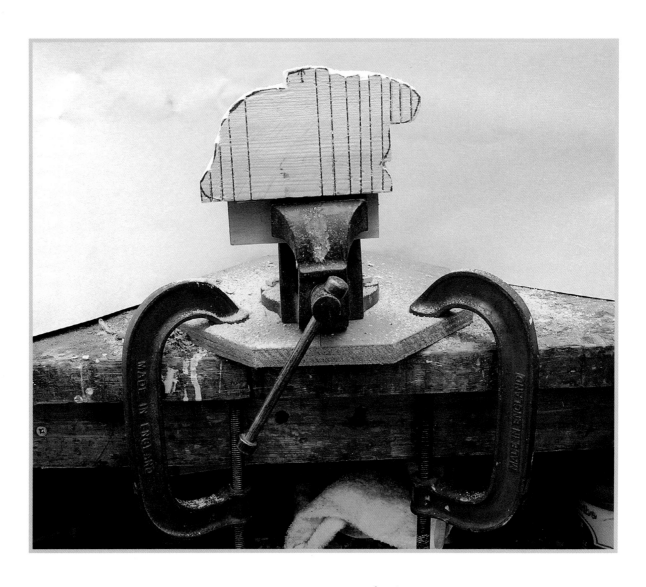

A simple set up consisting of metalwork vice bolted to a piece of 19mm (³⁄4in.) plywood which is held on the workbench with G clamps. By releasing the clamps the work can be conveniently positioned.

TOOLS AND EQUIPMENT

The main considerations to be made before beginning wood sculpture are:

1 Where are you going to make it?
2 How are you going to hold it while you work?
3 Which tools are you going to use in shaping the wood?

WHERE ARE YOU GOING TO WORK?

A shed or workshop is the obvious choice but certainly under cover, especially if you are using electric power for lighting or power tools. The different stages of sculpting wood will give varying types of waste to be cleared up. Early on there will be lots of woodchips and these will reduce in size as the work becomes more refined. Later, sanding will produce fine dust, and the main consideration will be that you protect your eyes and breathing. Always try to wear a dust mask; many wood-workers use some kind of dust extraction system which can range from portable units on hand sanders to fixed units that are more generally used for woodworking machinery such as band saws.

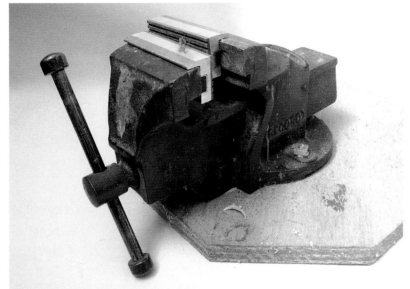

Rubber lined 'soft jaws', the far one moved to one side to show knurled steel jaws of the vice.

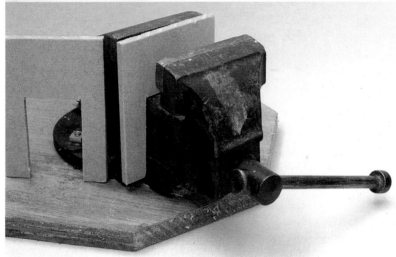

Home made soft jaws made of MDF board.

BENCHES AND VICES

Unless your timber is so large that it can stand on the ground while you carve it, then you will need some kind of bench. Quite often an old table is sufficient but if it does tend to move during some of the more vigorous stages of working then it can be fixed to the ground with brackets. The timber you are working with can be held down on the bench with clamps, screws or a vice.

There are several types of vice that can be used for wood sculpture, so what do we want from the ideal vice and where can compromises be made without too much loss of effectiveness?

There are generally two types of vice, a **woodworking** or **carpenter's vice** which is usually fitted so that the wood lined jaws are level with the top of the wood worker's bench and **metalworking vices** which always sit on top of the work-bench, usually bolted to the bench top. Their jaws are made of steel, usually with a knurled surface to give a positive grip, but

unfortunately they do mark wood easily. This can be avoided by fitting 'soft jaws' which are lined with hard rubber that fit over the steel jaws (see suppliers, p. 125).

A simple, home-made version of soft jaws can be made, using mdf or plywood, by cutting the board to the same width as the steel jaws and cutting a slot so that they fit over the vice screw cover.

Selecting the correct size of vice will depend on the size of sculpture you will be making. In this book all the projects will be made using a 7.5cm (3in.) metalwork vice (the measurement refers to the width of the jaws). It may surprise you how much pressure and power you will apply to your work so try to obtain a well made unit; I find it better to have a standard rigid version as opposed to one that swivels, because the latter sometimes moves when under pressure from heavy shaping.

Some vices have a screw fitting underneath so that they can be fitted to the edge of a table; these tend to move too much during sawing etc., but can be quite useful for sanding work when less pressure is exerted.

Woodworking vices are usually wider than metalworking vices and do not grip as well as the metal work ones because the wood-lined jaws tend to let the work to slip. They also have the major disadvantage that, because they are usually fitted level with the bench top, they are too low for most sculpture operations except initial sawing cuts.

For sculpture purposes a metalwork vice is usually more useful, but a woodwork bench vice can be very useful (as can be seen above). By its very nature the metalwork vice has the advantage of being mounted on the top of the work bench so as to give a better working height.

There are three ways that you can use your vice in conjunction with the bench:

1 **Bolt it directly** through the top of the bench, which gives maximum rigidity, but is a bit inflexible in terms of accessibility for working.

2 **Bolt the vice to a block of wood,** this block can be held in

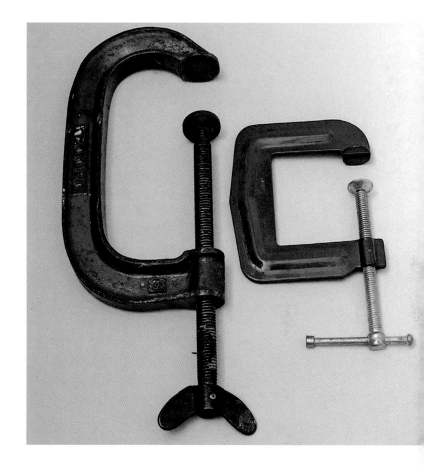

G clamps come in a variety of sizes and are always handy.

the jaws of a carpenter's or woodwork vice if you have one already fitted to your bench (see p.32).

3 **Bolt the vice to a wooden base,** made of 1.8cm (¾in.) plywood or similar material, that is either circular or octagonal in plan and big enough 30cm (12in.) square, so that it can be held on the bench top with two G clamps. As well as being very secure for working this method has the advantage that the sculpture can be turned for ease of working by simply releasing the clamps and repositioning the work. This is my preferred method and is probably the most versatile.

G clamps can be used to simply hold a piece of wood to a bench but this is usually a fairly restricted way of working.

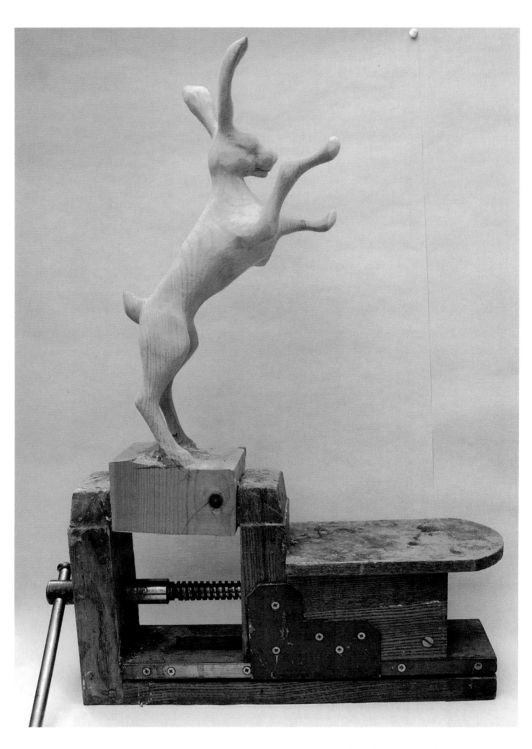

Carver's chops holding a sculpture in progress.

Carver's chops, really a large wooden vice, are a traditional method of holding wood for sculpture. Basically it is a wooden vice with its jaws made from thin leather-covered cork. Chops are expensive but kits containing the vice thread etc, can be bought at a more reasonable price. Chops are useful for holding larger sculptures because the jaws open very wide (available from Anthony Dew, see suppliers p. 125).

Other methods for holding wood for sculpting

There are various woodcarver's clamps and holding jigs for sale. The simple vice and board system is probably the most economical way to hold your work initially. Once you decide on the size and type of work you enjoy making then you will be better informed about your own requirements.

TOOLS FOR WOOD SCULPTURE

You will not need many tools to make wood sculpture. The projects in this book have been designed to use a minimum of tools and thus initial expense will be low. The first two projects need an absolute minimum of tools and these are all of the type that does not need sharpening. If you decide that wood sculpture is something that you intend to continue with, then for the later projects the acquisition of more and varied tools can be justified.

One of the biggest stumbling blocks for those new to wood work is the problem of sharp tools. There are two categories of tools in this respect:

1 Tools that are not intended to be sharpened, or that have replaceable blades, such as surforms, rasps, rifflers, hard point saws, coping, jig and band saw blades.
2 Tools that require regular sharpening in order to cut effectively and safely, such as chisels, some hand saws and drilling bits of all sorts. Hand saws and drilling bits are often sharpened by specialist tool stores for a small charge.

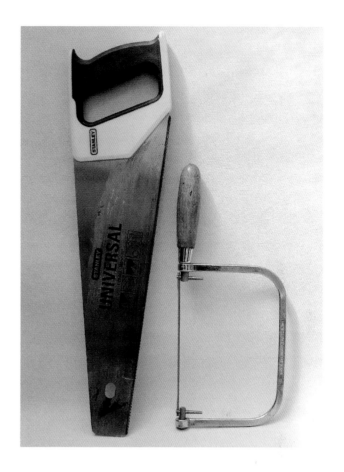

Hard point saw, left and a coping saw right

Saws

These are the most effective way of removing large amounts of wood (see chapter 5, Skills Training, p. 53). There are many types both for hand use and power driven.

Hard point handsaws are modern saws that are not resharpened, use them and when they cease to cut effectively just buy a new one!

Coping saws have a narrow blade that allows curved cuts to be made but they are difficult to use on timber more than 2.5cm (1in.) thick. Replaceable blades save sharpening, fit them with the teeth pointing towards the handle, so it cuts on the down stroke.

(Below) *Close-up view of a band saw showing the narrow blade and at the top the adjustable blade guide which can be adjusted to the thickness of the wood so that very little blade is exposed during sawing.*

(Top, right) *A small band saw. This tool can cut up to 15cm (6in.) thickness of timber saving a great deal of time.*

(Bottom, right) *The jigsaw is a very useful tool for cutting around curved shapes. Blades can cut up to 7.5cm (3in.) thick timber and this tool is especially effective for cutting plywood and other industrial sheet materials. The base plate must be kept in firm contact with the material being cut. Dust created from cutting these materials is removed via the extraction port to a portable dust extraction unit.*

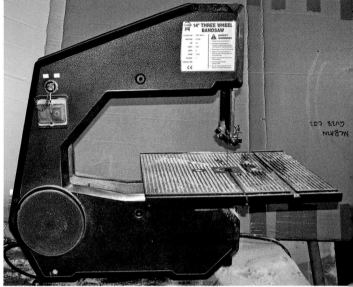

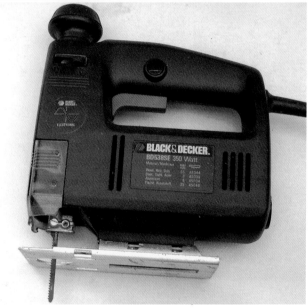

Band saws are very useful, and certainly worth considering as an investment as they save a huge amount of time because of their ability to make accurate curved cuts. If you are only intending to make a few sculptures then it is probably easier to pay for band sawing services. Doing this eliminates the problem of where to keep the machine and how to deal with sawdust generated. To a lesser extent a hand held **jigsaw** (see above) can be useful for making curved cuts in timber up to 7.5cm (3in.) thick.

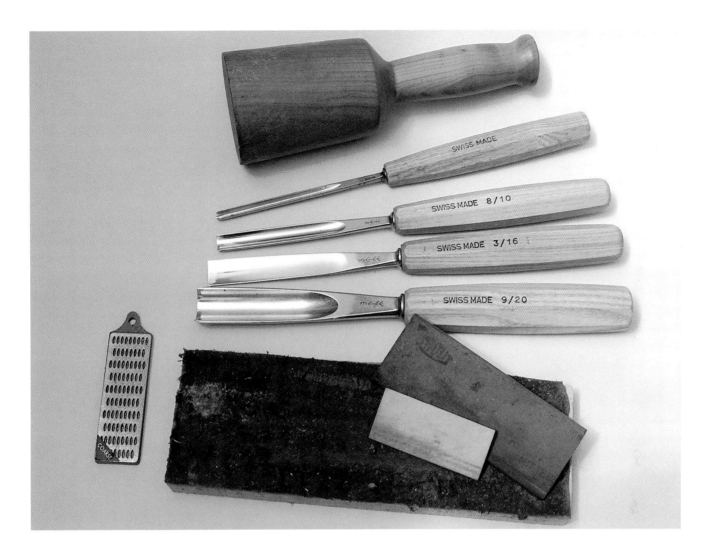

Selection of chisels that are very useful for wood sculpture. Also shown are a mallet, a small diamond sharpening stone, a leather strop and two sharpening slip stones.

Power tools obviously make cutting wood much quicker and involve less effort but not everybody owns or has access to expensive equipment. A great deal can be achieved with hand tools and a little healthy perspiration! So if you do not have a band saw do not despair, the projects in this book will show how hand tools can be used. The only project designed specifically for power tools is the tiger project – and this has two versions, so it can be made using either hand tools or power tools. Power tools are explained further on (see p. 48–51). (See bibliography for books that will advise you about buying and safe use of power tools.)

Chisels

These are not the easiest tools to sharpen and use, but once mastered are very useful. Modern power tools make it quite possible to make wood sculpture without ever using carving chisels; by using only flexible drive tools, complete wood sculptures can be achieved. The principles of model making, templating and removal of wood remain the same, but the method of wood removal is by rotating cutters.

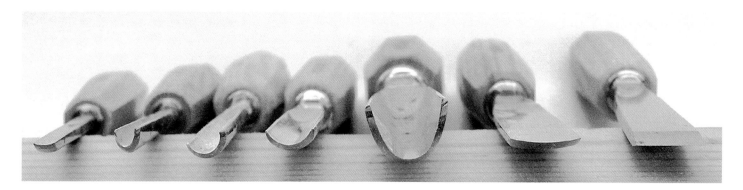

Photo showing a range of useful chisels end profiles.

A great deal of sculpture can be achieved with just a few chisels; so whether you buy chisels or not will depend on the way you prefer to make your sculptures. Many sculptors use both systems feeling that only the final result matters, not the means by which it is achieved.

The main uses for chisels are for removing wood efficiently, and for cutting-in detail such as toes, eyes, mouths and fins, which they will only do if they are sharp!

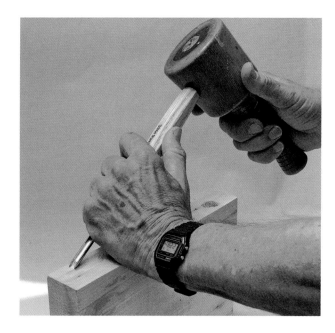

Using a chisel and mallet on a block.

The most useful chisel shape is the gouge; these come in a huge variety of options, and are described by:

• the curvature of the cutting edge,
• the width of the cutting edge and
• the type of shaft, i.e. straight or curved.

As well as gouges, there are straight, skew and 'v' or parting tool chisels.

This is a simplified description of woodcarver's chisels; if you enjoy using them there are many excellent books that give more detailed information, (see bibliography, p 127).

If you intend to work with chisels you will need some other equipment to maintain and use them effectively.
• Sharpening stones and slips, and a leather strop for keeping the tools sharp. These will be looked at in more detail in the section on sharpening.
• A mallet for assisting the chisel cut.

In the tiger project, carving chisels will be introduced and I will make recommendations for those tools that will generally be most useful for that project. The make of chisels that I recommend without hesitation are Swiss Pfeil tools, arrow brand, which I have found to be always of a consistently superb standard.

Although it will depend on your style of carving it is safe to

say that these chisels will always be useful. There are three details that describe a carving chisel. The width of the cutting edge (given in mm/in. – because Swiss tools are European the width of the edge is measured in millimetres), the cut number which describes the amount of curvature of the cutting edge, and the final part of the description is the shape of the shaft of the chisel, which can be straight, bent, back bent or spoon bit. At first, however, it is only necessary to use straight shafted chisels:

- 18mm (¾in.) or 12mm (½in.), cut No. 8
- 18mm (¾in.) or 12mm (½in.), cut No. 3
- 12mm (½in.), cut No. 5
- 5mm (¼in.), cut No. 3
- Veiner (very small deep gouges originally used for carving veins on leaves).

Mallets

Sculptor's mallets, sometimes called mauls, are traditionally made from hardwood. Generally, they are used to hit the chisel handle with a gentle tapping blow to simply help the chisel to cut. They differ from carpenters' mallets in that the head is a tapering cylinder. The purpose of this curved face design is that it allows the user to concentrate on the chisel's cutting edge, because the curved face of the mallet always gives a consistent strike to the chisel handle. Some mallet heads are now made from nylon, heavy plastic and even brass or aluminium. The advantage they have over wooden mallets that they do not split or fray after long usage, although their excessive use may cause increased wear on tool handles.

The choice of mallet depends to some extent on the size of chisel being used, so when using a large chisel to remove a bulk of waste wood, then a 10cm (4in.) diameter mallet would be appropriate (although if you are not used to using a heavy mallet, err on the side of choosing a slightly lighter one). However, when making more delicate cuts a 6cm–7.5cm

(3in.) diameter mallet would be a better choice; having a variety of mallets is very useful. Mallets are not always used to give a heavy strike, and in use generally, mallets are used with a gentle tapping blow to simply assist the chisel cut. Heavy-handed use of the mallet may cause damage to the finely sharpened chisel edge. I have read of one carver who uses a rubber mallet for gently tapping the chisel for delicate work.

SHARPENING CHISELS

What are the criteria that indicate that a chisel is sharp, apart from the obvious fact that it cuts wood? Many people hope that by rubbing a chisel on a stone for a time, it will eventually become sharp. There is no chance of that happening and sadly, the result is a chisel that still will not cut, so that the work is slowed or spoiled, a frustrated sculptor, and the inevitable loss of enthusiasm. The process of sharpening a chisel will depend on the condition of the edge to be sharpened. To clarify the terminology for sharpening, the following should help.

Bevel The area, ground at an angle, directly behind and including the cutting edge of the tool.

Grinding This is the fairly rapid removal of a bulk of metal from the face of the bevel in order to *true up* and correct the shape of the edge. This means flattening the bevel, removal of edge nicks and ensuring that the cutting edge is straight. Grinding can be carried out using a whet stone, which is a rotating stone wheel cooled by water, giving a slight concave surface to the bevel, which will be removed by *honing* (see below).

Grinding can also be achieved on a coarse bench stone lubricated with oil or water. The resulting bevel is called the grinding bevel.

Honing The removal of a small amount of metal from the grinding bevel to remove the coarse surface left from grinding

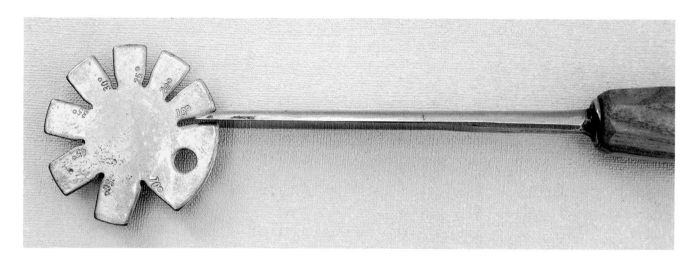

A brass angle checker showing the method for checking the angle of tool bevels. Home made versions using card or plastic sheet are probably finer and thus more accurate.

and give a fine sharp edge. Carving chisels are honed on the grinding bevel. For honing a fine bench stone is used (see p. 41).

Power stropping There are tool systems available for power stropping which consist of a motor with special polishing/stropping wheels that in cojunction with special

stropping compounds will give a very sharp edge to chisels. They have to be used with care or they do tend to round over the bevel on the chisel (called dubbing over the edge),. Another system is a home-made piece of equipment that consists of a motor with a flat disc on which is glued a piece of leather; a sharpening compound is used to give a good edge. This system of stropping is illustrated in Ian Norbury's book *Techniques of creative Woodcarving*.

In order for a carving chisel to be correctly sharpened the following three points must be established.

1 **The shape of the cutting edge of the blade.**
2 **The angle of the bevel and its position.**
3 **The nature of the bevel**.

1 **The shape of the cutting edge** generally should be straight as this allows the chisel to be used right up to a vertical

Tormek whetstone, grinding wheel on the right and buffing or stropping wheel on the left. The yellow template at the front indicates various bevel angles.

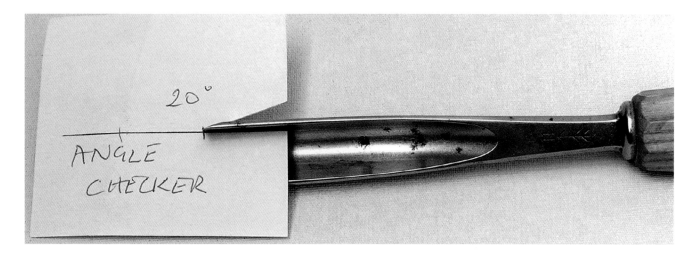

Home made angle checker used to ensure the bevel is correct.

plane. If the edge is concave this becomes more difficult, as the wings or outer edges contact a vertical surface before the centre part of the blade can cut cleanly, and if the blade is convex then the centre part of the blade may under cut a vertical plane before the wings have completed their cut. That said, many carvers do deliberately give their chisels a convex curved cutting edge.

2. **The angle of the bevel and its position.** There are two options for bevels on carving chisels, either:
 - The internal face is flat and the outer one has a bevel. (This is the system I use.)
 - Both faces bevelled, either of equal or unequal angles. The included or overall angle is usually 20 degrees depending on the hardness and bulk of wood to be removed. A 2cm (¾in.) gouge used for heavy cutting on hard wood would probably be best sharpened with a bevel of about 25 degrees.

3 **The nature of the bevel.** Carving chisels differ from carpentry chisels in that, whereas carpentry chisels have a grinding bevel of 25 degrees and then a honing or sharp-

ening bevel of 30 degrees, carving chisels are *ground and honed on the same bevel which is commonly 20 degrees.* Correct bevels, which once established on either a coarse bench stone or whetstone, can initially be flat or slightly concave, but after honing, should always be maintained absolutely flat. A bevel-angle checking tool is easily made using a piece of card. Using a protractor and pencil to draw 20 degrees on some thin card, cut out the wedge and this will give a serviceable gauge to check the angles of the bevels on the chisels.

Sharpening stones

To keep carving chisels sharp you will need a medium and a fine **bench stone**. They are rectangular with a dimension of up to 20cm (8in.) long and about 7.5cm (3in.) wide although smaller stones of about 15cm (6in.) by 5cm (2in.) wide, work adequately. For truing up the inside of gouges, a small selection of **slip stones** which vary in size and can be as small as 5cm (2in.) by 2.5cm (1in.) and 1 cm (⅜ in.) thick or as large as 5in. (12.5cm) by 4cm (1½in.) and about 1.5cm (½in.) thick. They are usually wedge shaped, the thick and thin sides being rounded giving two different radiused edges to allow the stone to fit inside a

range of internal curvatures of gouges to be sharpened.

There are many sharpening stones available today. Originally sharpening stones were just that, pieces of local stone that were prized for their ability to give a sharp edge to tools. There are still some natural stones that can be purchased today e.g. Washita stones used for slip stones. Water stones are much used by Japanese tool users and can produce an incredibly sharp edge, however they do need to be maintained very carefully.

Artificial stones offer a consistent quality, and have a variety of textures from coarse to very fine. Typical names for these are carborundum and India. They do tend to wear 'hollow' with use and need to be dressed by grinding them on a coarser stone, to keep them flat, which is tedious.

Diamond impregnated plastic 'stones' are available using a variety of grades giving a range of cutting ability from coarse to medium and fine. The stones vary in size from credit card to approximately 20cm (8in.) by 7.5cm (3in.). These stones are fairly expensive but have the advantage that they do not become 'hollow' after extended use. The plastic sides on these 'stones' are colour coded so that it is easy to identify the grade of a given stone.

Black (coarse) is ideal for grinding.
Blue (medium) for general sharpening.
Red (fine) which gives a fine-honed edge.

They are my first choice stones for sharpening carving chisels.

Sharpening – the process

When sharpening, remember that you must look at the chisel very often.

(I shall refer to the 'stone' although the sharpening system being used may be made from some other material.)

Try to position the stone on your workbench so that when you hold your chisel at the correct angle (20 degrees) you are standing comfortably; if not, your body will impercep-

tibly but gradually straighten up and as a result, the angle at which you began honing your chisel at will change, which will result in an uneven and multifaceted bevel. If your work bench is too low for your height, then use a block of wood to raise the stone to a comfortable working height, making sure that it is firmly fixed so that it is stable in use. Sharpening stones can be lubricated with either water or oil. One advantage of water is that there is no chance of transferring oil from the stone to your work, which could cause permanent staining.

Both oil and water should be removed from the stones as soon as sharpening is completed and stones should be kept separate from the cutting area when they are not being used, as wood dust will clog them and reduce their efficiency.

Sharpening using the one bevel method

Grinding the bevel

Grinding is the process of using a coarse bench stone or rotary grindstone to remove excess metal from the bevel of your chisel. It will only be needed rarely; on some new chisels that have been badly sharpened, on secondhand tools that have been abused, when an edge is accidentally chipped or to occasionally flatten a badly honed bevel.

Stage 1 With a coarse bench stone, lubricated with a little water or oil, true up the edge to remove any nicks and make the edge straight. This is done by holding the tool at 90 degrees to the stone and drawing the edge of the blade firmly along the stone, removing as little metal as is necessary in order to leave a clear silver band on the straightened edge.

Stage 2 In order to see what is going on when you are grinding the bevel on the stone it is a great help if, before you start, you cover the bevel with waterproof blue marker pen.

When sharpening starts, you can see exactly which part of the bevel is being honed and so, if necessary, slightly adjust the angle at which you are applying the tool to the stone.

Mark the bevel as often as you like to help improve your sharpening technique.

I use the system of sharpening that uses only one bevel, and this on the outside of the gouge, i.e. convex side of the tool, and I only use a slip stone to remove the wire edge from the inside face (see image left, p. 45).

Stage 3 Stand facing the workbench with the long side of the bench stone parallel to, and about 25cm (10in.) from the edge of the bench nearest you. Position the chisel, at right angles to the long axis of the stone, handle toward your stomach, on its outer bevel. Lubricate the stone and apply the outer corner of the chisel at one end of the stone, bevel at the correct angle.

Stage 4 Keeping the sharpening angle constant, move the chisel at right angles to the direction of travel to the other end of the stone, and as you move along the stone, rotate the chisel about its long axis, so that by the time you have finished the stroke at the other end of the stone, the bevel of the opposite outer corner is in contact with the stone.

Try a few passes with the chisel along the length of the stone and then look at the bevel. The blue marker pen will have been ground off where the tool has been in contact with the stone leaving the silver colour of the steel showing. Remember to maintain the angle of the tool on the stone (ensure you are sharpening at the correct bevel angle by using the home made angle checker. Brass angle checkers are available from good tool suppliers).

Make sure that in one pass along the stone; the bevel is ground from side to side. Check how accurately you are grinding by looking to see where the marker ink has been worn off. Again, do not be afraid to recoat the bevel with ink at any time during the sharpening process, but most especially in the early stages when getting the sharpening technique correct is vital. By looking at where the marker ink is worn away, you can work out how to change your technique in order to get the correct grinding angle. What are you looking for? An even silver line halfway between the edge of the blade and the heel of the bevel and most

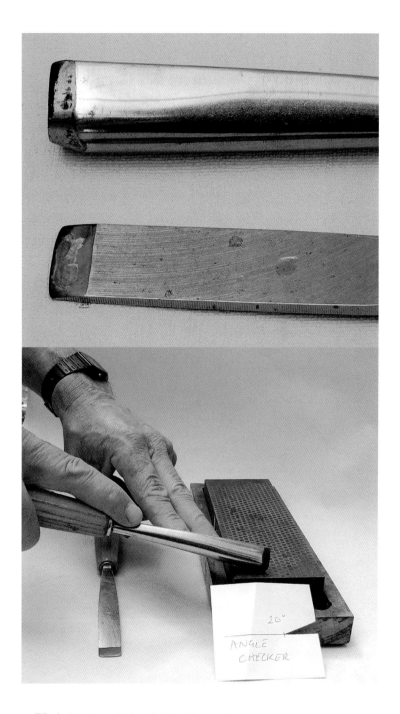

(Top) *Bevels marked with blue felt pen showing wear patterns that will help you improve your sharpening technique.*
(Above) *Photo showing the beginning of the stroke for sharpening a gouge. Keep the tool at right angles to the bench stone throughout the stroke.*

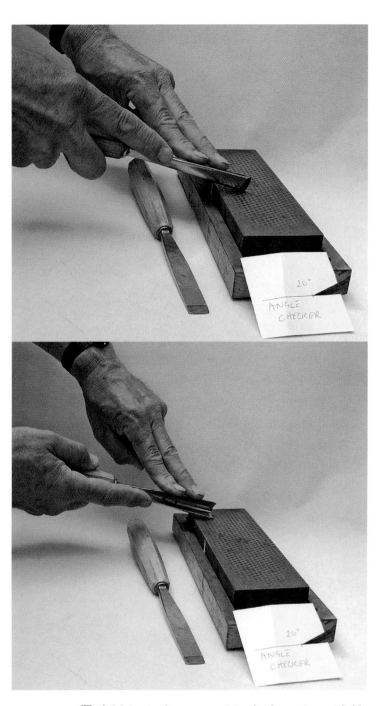

(Top) *Maintain the correct position for sharpening, guided by the felt pen ink. Note the straight chisel bevel coated with ink ready for sharpening. Angle checker by front of the stone.*
(Above) *The end of the stroke, the gouge has been rotated from one edge to the other as it has been rubbed along the bench stone.*

importantly, the silver line must extend from side to side of the bevel. As you continue sharpening the silver band gets wider, until the whole bevel is silver and flat. Don't give up! This is not easy, it takes concentration and patience but it does become easier. Keep using the felt tip pen and checking that you are sharpening accurately.

Stage 5 Grinding in this way continues until the edge becomes very fine, and in fact what happens next is that the metal edge being ground becomes incredibly thin and rather than being ground away, as it is rubbed on the bench stone, it bends away and forms a thin strand of metal. This is called the 'wire edge' and indicates that the bevel is ground as far as is necessary to create the grinding bevel. The wire edge often just falls off when it is wiped with a piece of cloth.

Because gouges are made by forging, the metal of the blade is sometimes not quite of an even thickness and so although the bevel may be ground perfectly, the edge may be slightly uneven and this has to be corrected by using a slip stone on the inside or concave side of the gouge. If this is the case then it can be corrected at the next stage when the edge is honed.

Honing

Use a fine bench stone positioned as in the grinding position, (see above) and use the marker ink method to ensure that the tool is correctly applied to the stone. Keep the tool at a right angle to the direction of honing and, very importantly, roll the tool completely from side to side, as the tool is moved along the stone, so that the bevel is evenly honed. It is very important to check the bevel about every five passes along the stone, because in the early stage of honing it is very easy to go wrong and if you do not check the state of the bevel then it will take extra time to correct the mistake. Honing continues until the 'wire edge' occurs again, and this is the indication that honing is complete and all that remains to do is remove the 'wire edge' by very careful application of a fine grade slip stone (see stage 5, above).

Slip stone being used to clean off wire edge and hone inside of a gouge. Note that it is flat on the inside of the gouge.

Stropping a chisel.

A word of caution. The slip stone must be held absolutely flat against the inside of the channel as it is rubbed up and down while honing the inside edge. Failure to keep the slip stone flat will cause the formation of an internal bevel which effectively changes the included angle of the bevel to well over 30 degrees and as a result a huge loss of effectiveness when fine cutting is needed.

A coarse slip stone is advisable in the early stages, in order to remove excess metal as quickly as possible. Having gone through the process you may find that the chisel may still not cut evenly. Look carefully at the edge to see if there are any flat or ragged areas, which need to be tuned in with the fine slip stone.

LEATHER STROP

Once the cutting edge has been honed to a very sharp edge it should be maintained as long as possible by stropping. The strop is made from thick buff leather about 20cm (10in.) long and 5cm (2in.) wide, 0.3cm (⅛in.) thick; the suede side is dressed with an abrasive compound mixed with a binder that sticks it to the leather. Years ago the abrasive compound was Crocus powder bound in Russian tallow. Nowadays the most usual abrasive is a green chrome-based compound bound with an industrially made soft grease base.

Stropping

Although the sharpening process seems like a lot of work, in normal use honing is not required very often, provided tools are handled carefully and kept in a way that they do not come into contact with other tools or the floor; then the edges will last a reasonable time. One way of maintaining a good edge is by stropping the chisels every few minutes while the tool is

being used, on a leather strop that is dressed with a fine abrasive strop dressing. This is done by drawing the tool along the strop, bevel rubbing and trailing the sharp edge, between five and ten times using a firm pressure. This polishes the bevel to a mirror finish and gives a very sharp edge. The strop needs to be kept free of dirt and grit so is best kept covered when not in use.

Rasps and files

This family of tools is extremely useful to the sculptor as they do not require sharpening, are safe to use and give a controlled method of wood removal. In fact, complete sculptures may be made using just these tools, as in the first project, The Dancer.

The choice of tools is wide and for the beginner a bit daunting. Looking at the general groups of tools in this category there are:

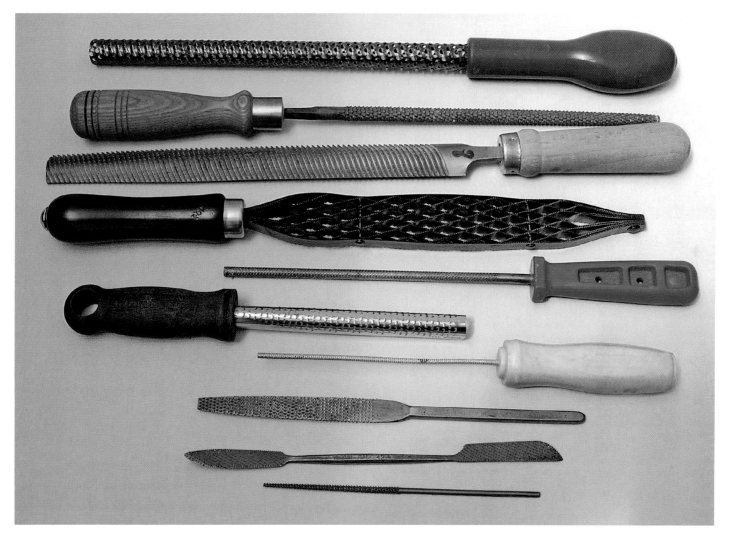

A selection of tools from the top, round surform, rat tail rasp, dreadnought rasp, Japanese saw rasp, small rasp, round micro plane, fine rasp, Vallorbe rasp, riffler rasp, needle rasp.

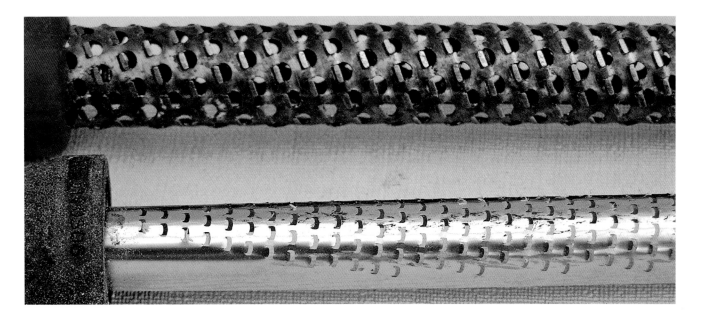

A close-up view showing a comparison of tooth size between the coarse surform, (top), and the fine micro plane (below).

- Surforms and microplanes are basically 'wood graters' and remove stock the quickest of the tools in this category but leave the coarsest surface, the surform being the coarser of the two. I find the round surform extremely useful. Apart from a hardpoint saw it would be my first acquisition for sculpting. Microplanes do a similar job but, cut more gently and leave a finer finish, so are more appropriate for smaller work.
- Rasps and files are similar. A file is a piece of hardened steel that has teeth cut into the surface in rows, more usually intended for cutting metals and other hard, dense materials, although they tend to clog up, they do have a use in wood sculpture, usually as part of the finishing process. A rasp is a piece of hardened steel, but in this case the teeth are proportionally larger and individually cut, usually giving a generally coarser cut and thus removing material more quickly than a file.

A **riffler** can have teeth cut with either a file, or rasp pattern, its identifying feature being that it generally has two ends shaped in a variety of formations ranging from spatulate to cylindrical, with the middle portion acting as the handle. Rifflers, particularly the rasp type, are very useful for modelling shapes that are hard to get at with a conventional rasp.

A new generation of rasp/abrasive tool is now available. These are basically a metal core coated with a variety of abrasive granules, which may be diamond or tungsten carbide based. There are also various forms of rotary rasp that are designed for use with power drills and flexible drive machines.

DRILLS

Making holes using hand tools can be accomplished in two main ways:

1 With a wheel brace, usually suitable for drilling holes of a diameter of up to 1cm (⅜in.).

2 For larger and deeper holes by using a swing brace, which will cut holes up to 5cm (2in.) in diameter and 15cm (6in.) deep with some effort.

Power drilling can either be by a hand held power drill (mains powered or rechargeable). Use in conjunction with a drill guide for accuracy (see image top right, p.49). Bench or pillar drills, are obviously more expensive tools, but incredibly useful, because they drill very accurately. A pillar drill was used for the drilling on the tiger project. However a word of caution, whatever you are drilling, however big or small, it must always be firmly held, either in a drill vice, cramped to the drill table or work bench. If you try to hold the object you are drilling and the drill jams you will either be looking for a band aid or worse, a doctor!

Drill bits

As with most modern tools there is an overwhelming number of drilling bits available, so which ones should you choose? Twist bits can be used in all types of drill and are generally used for making holes up to 1.5cm (½in.) in diameter.

Swing braces using Irwin twist bits can cut accurately and safely up to 5cm (2in.) diameter holes. Spade or flat bits are very handy although, because they are generally of a cheaper manufacture, they tend to blunt fairly quickly. They can be used in either type of power drill, although I would be cautious about using any drill size above 2.5cm (1in.) in a hand held drill. Saw tooth bits should only be used in bench or pillar drills, and are very good for making large diameter holes up to 7.5cm (3in.).

Carving drill bits not only drill directly into wood but also, by adding side pressure, will enlarge the size of the hole being

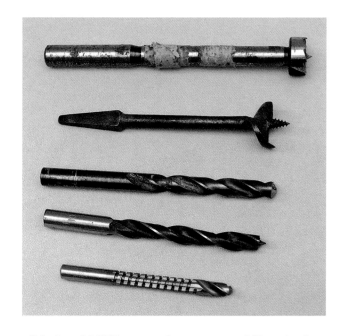

Selection of drill bits – top to bottom, saw tooth bit, swing brace bit (square end), twist bit, twist bit sharpened 'lip and spur', hole enlarging bit.

drilled and by further manipulation can make all sorts of negative shapes in the work piece.

Flexible drive and rotary power tools

As with all systems there are advantages and disadvantages, the biggest disadvantages of power carving being noise, dust and vibration which causes fatigue. The advantages are undeniable too, difficult grain is more easily cut, fine detail becomes more achievable and for sculptors with restricted movement it can be a great help. This is a specialist subject and there are many books dedicated to the subject (*Power Carving* by Frank Russell covers this area – see bibliography).

Hand held rotary shaping tools and flexible drive shaft machines are very versatile and can be used to add fine detail to a work piece; increasingly they are used throughout the complete sculpture. These tools, consisting of an electric

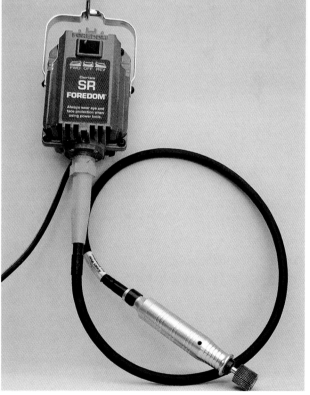

(Above) *Pillar drill set up for drilling. Note the block to be drilled is securely clamped to the drill table.*

(Above right) *Drill in position using drill guide. Guides for various driill sizes allow for a variety of hole sizes – the guide ensures that the drill is absolutely perpendicular to the surface that is to be drilled.*

(Right) *The Foredom flexible shaft machine. A small flap sander is fitted in the hand piece.*

motor, usually suspended on a hanger, which drives a flexible shaft that terminates in a hand piece in which accessories of various types are held (see photo above). The main disadvantage of

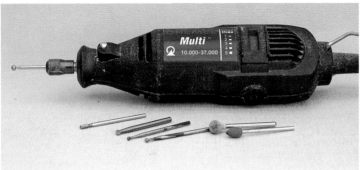

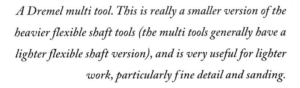

A Dremel multi tool. This is really a smaller version of the heavier flexible shaft tools (the multi tools generally have a lighter flexible shaft version), and is very useful for lighter work, particularly fine detail and sanding.

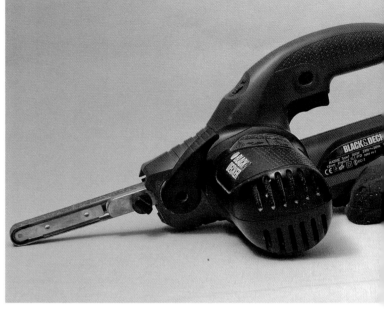

The power file. Note the dust collecting bag just below the handle slot.

these machines is that they create a lot of dust, so extraction of some sort is essential. Some machines may also cause vibration which can cause circulation and nerve problems for some people. Generally if common sense is used and the machines are used in moderation then problems should be minimal. As always, follow the manufacturer's recommendations. There is a huge range of flexible drive tools and cutting bits and once you go down the power carving route you will be amazed at the equipment available.

Generally the cutting and other accessories used in flexible drive machines can be grouped according to their use:

- **Tungsten carbide burrs** – come in a variety of shapes including ball, cylinder, cone and as a sleeve that mounts onto a rubber mandrel. Used for roughing out and shaping.

- **Ruby carvers** – finer than the burrs, used for final shaping and smoothing.
- **Diamond carvers** – these are more delicate than the ruby carvers and are used for very fine detailing.
- **Ceramic abrasive bands and discs**, 60, 80, 120 and 220 grit – for final sanding.

There are many other accessories that can be used with these incredibly versatile machines. A lighter alternative to the flexible drive machine is the multi-tool such as the Dremel, which is a smaller version of the flexible shaft and is particularly useful on small sculptures, especially for fine detail and sanding.

As with all machinery, it is vital to follow the manufacturer's instructions about safe use and working conditions.

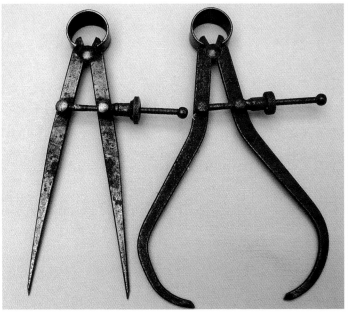

Dividers and right bow leg callipers. The screw adjusting type is to be preferred because they give a positive measurement.

The glue gun has a heating element that melts glue rods that fit in the back and are pushed forward with the operator's thumb which allows a control of hot glue flow. The glue sets as it cools giving a quick and effective hold. Useful for temporarily re-affixing wood while band sawing and also fixing work to bases.

Other power tools

One very useful tool is the power file which basically is a narrow band sander. It uses belts 1cm (⅜in.) wide and they can use abrasives with a huge variety of grades from 60g (coarse) to 300g (fine). Because of the light weight of this type of machine it can be used for fairly delicate sanding without the risk of damaging the work.

Other power tools will include items such as chainsaws, both petrol and electric powered, angle grinders with arbotech cutters and abrasive attachments. These are really advanced tools and beyond the scope of this book; anyone wishing to develop their sculpture to that level will be well advised to seek professional advice and perhaps attend specialist chainsaw training courses or similar activities.

Other non-shaping tools

Apart from tools for cutting and shaping the wood, you will need equipment for other operations in the sculpting process, such as paper to make sketches, notes and templates, some modelling medium and tools, fine-bladed scissors, and some method of comparing your wood sculpture with your model during the process. These can be dividers, callipers or even homemade measuring devices using scraps of wood, string or paper. A hot glue gun is also a useful item, although not essential.

Raising blocks used to increase bench height.

SKILLS TRAINING

To make sculpture you will need woodworking skills; once you are able to shape wood accurately then you can concentrate on the artistic element of your sculpture. As we established in the previous chapter the tools traditionally used for wood sculpture have been saws, chisels, rasps, rifflers and finally sanding with abrasive papers. In recent years, flexible drive machines have become very popular and the newer and improved carbide cutters make wood removal very efficient. These flexible drive systems also open up great options for people with restricted mobility. Dust removal systems are essential with flexible drive tools, as with any power tools, especially when sanding.

To save time and effort never chisel or rasp wood that you can remove by sawing; never sand wood that you can remove with a rasp or chisel. In other words removing wood with a saw is quicker than chiselling or rasping, which in their turn are quicker at removing wood by sanding with abrasives.

The first consideration when sculpting should be the position or height of your work; if it is incorrect you will soon have a bad back and find it extremely tiring and awkward to work efficiently. The best height to work at is when you are applying tools at approximately elbow height, while you are standing relaxed and comfortable. (This does not include when you are sawing, see p. 55.)

Tables and workbenches can be made higher with raising blocks. These are blocks of wood that increase the height of the bench to the correct level and have small pieces of plywood projecting about 25mm (1in.) above the top of the blocks, fixed on all the side faces of the block creating a well into which the bench leg can be located, giving a secure correct working height.

The correct height for working

MARKING OUT

To create accurate work it is essential to first mark the place that you intend to cut. Use an HB pencil or a fine felt tip pen, but beware, the ink may bleed into some timbers. Make clear lines in a position that has been carefully measured and double-checked for accuracy – there is no point having good woodworking skills if your marking out is inaccurate.

Your initial marking out will almost certainly be around the templates. It is usually good practice to mark a centre line on your work; if it is removed as a result of sculpting, remark it immediately. The centre line is a very useful point from which measurements can be made. Another important feature of marking out is the way you indicate wood that is to be removed. It is usual to show this 'waste wood' by a series of parallel lines marked on the wood to be removed (see photo on p.77). To mark out accurately you will need measuring tools. The most commonly used of these are bow-legged callipers and dividers, as well as a ruler (see photo on p.51). Bow-legged callipers fit past projections on the work and are used to transfer and check measurements from your maquette to your work, while the dividers tend to be used for measuring lengths and distances.

The try square is an essential piece of equipment. It has a stock (the thick part) and a blade (the thin part). Its sides and faces are straight and square (at right angles) to each adjacent face. Used in conjunction with face side and face edge marks, accurate marking out can be achieved.

Wood sculpture is, of course, about removing small pieces of wood from a larger piece to leave the desired shape. Whichever tools or abrasives are used, there is a fundamental concept that should be borne in mind. Whenever possible, although you may have cut, chiselled, rasped and/or sanded across the grain of the wood, try to make the finishing strokes of whichever tool you are using, in the direction of the length of the grain. This will help when you come to the next stage and finally finish the surface (even if you are going to wire brush or air abrade it). Remember the concept of sharpening a pencil with a knife and if you cut in the direction the wood prefers to be cut, then the tools and wood will be at their most obliging.

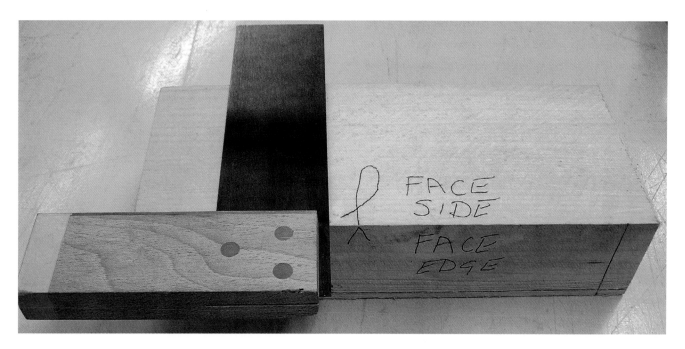

Block marked with face side and face edge marks. Try square with stock applied to face edge.

SAWING

Once the initial marking on the wood is completed, then the waste or unwanted wood of the sculpture block, indicated by hatch marks, has to be removed. Unless there is a good reason not to do so, the bulk of the waste can be removed with a saw. The first three projects are made using only a hardpoint panel saw for the bulk of the waste wood removal. Nobody can work accurately with a blunt saw so obtain a sharp (new) saw and look after it. Hide it from your loved ones if you have to!

Using a saw accurately begins at the soles of your feet. Hold the saw handle, your index finger pointing forward. To saw alongside a line, on the waste side, of course, first align the saw along the line on the waste side. To avoid the saw binding or getting stuck as you cut the next step is essential. Keep the saw aligned with the line to be cut and visualise an imaginary straight line running from the tip of the saw through the centre of the handle, through the centre of your elbow and up through the centre of your shoulder. Move your feet so that the imaginary line can be maintained as you stand relaxed when you prepare to saw.

If you do not maintain this line, the saw will jam and you will not be able to cut accurately. Once you are in the correct sawing position, gently draw the saw back across the wood two or three times, until a small groove is cut. Next, gently push the saw forward, at this stage not pressing down on the handle but just allowing the weight of the saw to do the cutting. Let the saw glide or float gently over the surface you are cutting. Once the cut is established, increase the length of stroke and gradually allow the cut to deepen. Do not put any weight on the saw, just allow its weight to carry the blade through the wood as you push and pull evenly on the handle. The rule of cutting is, only cut to a line you can see. Cut down alongside the line that you can see and then turn the wood around so that you can then see the line on what was the unsighted side, and then cut to it. It is definitely worthwhile practising sawing on a spare piece of wood because it is a fundamental skill.

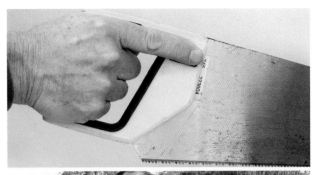

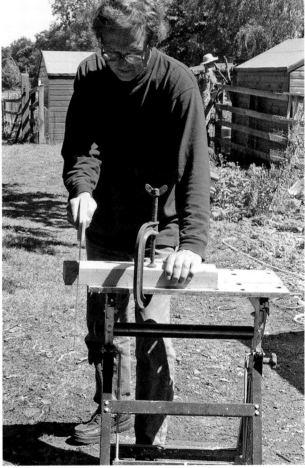

(Top) *The correct way to hold a panel saw. The index finger alongside the handle helps to keep the saw in the correct alignment. The old carpenters used to say 'magic finger forward'.*
(Bottom) *Sawing, make sure the work is held firmly, here it is cramped to the bench, align yourself, the saw and by moving your feet, your body, as explained in the text.*

Chiselling using the mallet, the heel of the hand holding the chisel is in contact with the wood, to give greater control of the chisel cut.

Two handed chiselling, the choke hand is in contact with the wood to give greater control of the cut.

CHISELS

As we said in the chapter on tools and equipment, pp. 31–51, there is a vast array of chisels available but wood sculpture can be made with relatively few. Chisels have the advantage of removing large quantities of wood quite rapidly, but their great disadvantage is that they do need to be kept sharp. The best way to approach using a chisel is to take delicate cuts at first and if the wood chip comes away cleanly then try a deeper cut and so on. There are many accounts of how to cut with the grain, but the problem is that wood rarely grows as shown in books. What is most important is that you keep your hands clear of the cutting edge by either keeping both hands hold-ing the chisel or one hand holding the chisel and the other holding the mallet. Any other permutation will quite probably lead to an accident. The mallet is designed to assist the chisel; a double tapping blow should be all that is necessary to make effective cutting. Surprisingly, very fine carving is probably more easily performed by very gently tapping the chisel with a mallet. Using a mallet is more accurate and much less tiring than two hands holding the chisel, however there will be occa-sions when the mallet is not used.

If you are chiselling using both hands on the chisel, it is usual to grip the butt of the handle with one hand while the other hand grips the chisel where the metal shaft joins the wooden handle (sometimes called the neck) and this is some-

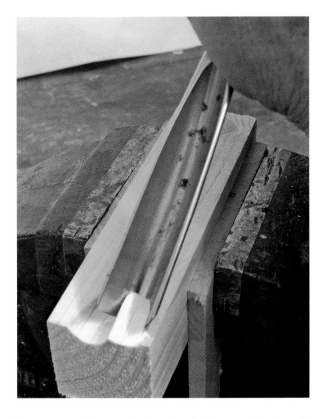

Whenever possible try to chisel so that the chip is easily released, i.e., at the end or edge of the wood.

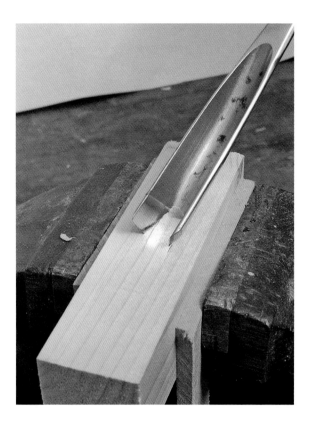

Cutting into a block where the chip is trapped and cannot easily be released can result in a chipped chisel edge and split wood.

times called the choke grip. The important point is that the heel of the choke hand is in light contact with the surface of the wood allowing a pivoting action as the tool is cutting. If no contact is maintained between the choke hand and the wood then the ability to control the chisel is lost or very reduced.

The cutting edge of a chisel is thin and brittle and is easily chipped. With this in mind, never sink either or both corners of your chisel beneath the surface of the wood. If you are cutting down into the wood and the end of the chisel has to be sunk into the wood, make the cut so that only fine wood chips are taken off and never cut so deep that the chisel is stuck in the wood.

SURFORMS AND MICROPLANES

These tools are just brilliant; they are safe to use, they cut fairly quickly and do not need to be sharpened (see photo p. 47). The surface they produce can be quite coarse, especially on soft woods, as they can tear and pluck the grain, but this is fairly easy to remedy with coarse (60g) abrasive. With your work held firmly with a vice or clamp, wood is removed from the main piece using a two handed grip and cutting on the push stroke. I find the round or tubular surform most useful, its only drawback being that shavings tend to clog inside the cutting tube, but they are easily removed from the back slot with a small blunt screwdriver.

RASPS AND RIFFLERS

Rasps are available in a huge range of shapes and sizes, including flat, half round, triangular and round (see photo on p.46). Generally the cut is finer than the surforms and they are usually used to refine shapes made by the former tools. Rifflers, being shaped at their ends, have a special usefulness for modelling and refining shapes and forms. They are usually used with 'one hand', sometimes being assisted by finger pressure on top of the blade.

DRILLS

When drilling always clamp your work firmly to prevent it spinning round. Probably the simplest hand drill is the wheel brace which is best used with twist bits up to 9mm (⅜ in.) diameter.

One of the power tools that I find to be a terrific timesaver is my cordless hand drill and I tend to use it, in conjunction with twist drills to pierce my work.

Larger sections of wood can be removed with saw tooth bits (see photo on p.48) and these are most safely used in a power bench or pillar drill. Flat bits have to be used in a power drill as do the carving drills, which enlarge the hole they make because they have cutters along their length. Bits with a tapering square shaft are intended to be used with a swing brace. Very useful, even if old fashioned, if you need to make larger deep holes where there is no power source.

BAND SAWS

The band saw can save an enormous amount of time if you have access to one. It is essential, however, that you are adequately trained in safe band saw use before you attempt to carry out the following technique. The object is to cut out both elevations of a piece of sculpture at one visit to the saw.

I have used a banana as the example because it is a simple familiar object. This method of cutting could be used on both the rabbit, shark and tiger projects.

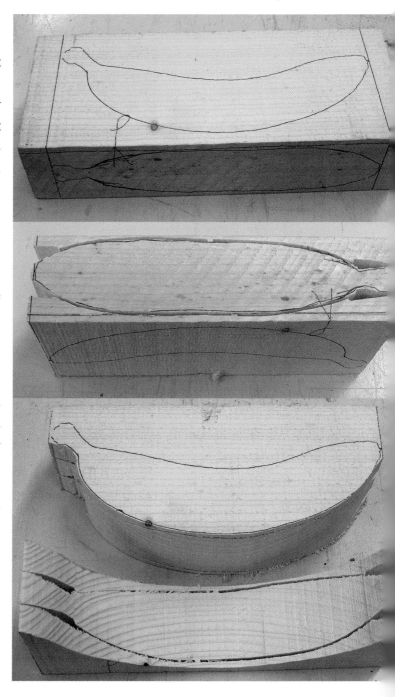

Mark the side and plan templates on the block; note the squared lines at each end to ensure registration or lining-up of the templates.

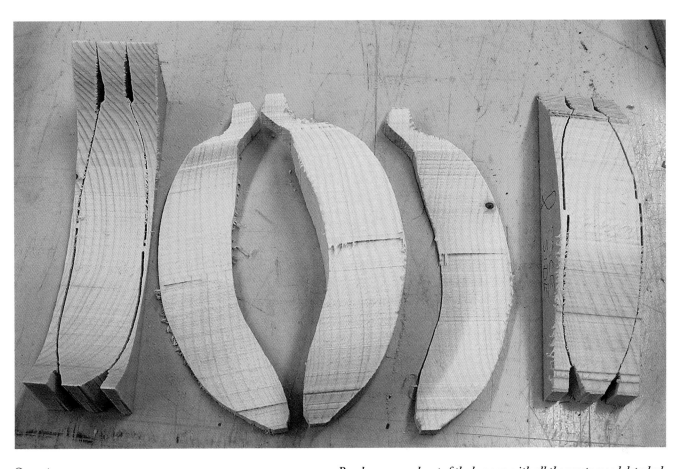

Opposite

(Top) *Block marked ready for sawing.*

(Middle) *Plan view sawn from each end leaving 'bridges' to keep the waste wood in place.*

(Bottom) *Block shown after first side cut has been made.*

Band sawn rough out of the banana with all the waste wood detached.

Next, band saw along the plan outline from each end and leave a small 3mm (⅛in.) 'bridge' just holding the waste wood in position. Make this cut along both sides of the plan lines. This means that the side waste piece, with the side elevation drawn on it is available for the next cuts.

The last stage is to lay the wood side elevation drawing upwards and cut all around the outline.

Finally break the remaining pieces of wood from the sides of the banana and there is the band sawn rough out.

If some of the off cuts become detached during the first stage of cutting, they can be temporarily held in place using tape or even tacked in place with a glue gun while the second face is cut.

Reverse side of some abrasive sheets showing grade or grit particle sizes.

CHAPTER 6

ABRASIVES AND FINISHING

Abrasives produce dust which is now recognised as a potential health hazard and must be collected by extraction or eliminated as it is produced. A further defence against dust can be provided by the wearing of a dust mask, which can be anything from a simple cup type to sophisticated, personal integrated, cordless fan-powered units. Power sanding produces a great deal of dust, but even hand sanding can generate unacceptable amounts. In a confined space, such as a workshop, some form of dust extraction is essential. Bench-mounted dust extractors are available which should cope with the dust from hand sanding, but ideally for power sanding, a dedicated dust extractor connected to any power sanding machine is the minimum health and safety requirement. It is possible to make home-made dust extractors (one very useful version is the one designed by and illustrated in the book *Carving Realistic Animals with Power* by Frank C.Russell, see bibliography p.127). At the very least, you must wear a good quality dust mask while you are sanding your work.

Sanding is a general term used to describe any process that involves the smoothing of the surface by abrading it with abrasive grains attached to a paper or fabric backing, which is either hand held or attached to a sanding machine. Originally sand paper was just that, sand glued to a sheet of strong paper;

later crushed glass was also used, giving glass paper, which produced a finer finish and was used by cabinet makers to achieve a high quality finish. Manufactured abrasives have been developed, which retain their cutting effectiveness longer than sand or glass; the main ones used by woodworkers are aluminium oxide and synthetic garnet. These industrially-produced abrasives can be graded very accurately in terms of size of grain particle and this is indicated on the back of the sheet by way of a letter P followed by the particle size, e.g. P120. Abrasives are usually referred to either as P120 or 120g. The lower the particle size, the coarser the abrasive; the higher the number the finer the particle size; so 60g is much coarser than 500g abrasive paper.

The type of backing that the abrasive particles are attached to makes a difference to the handling and working life of the abrasive sheet. Paper-backed abrasives are cheaper than those on a cloth backing, but will not last as long and are less flexible. Paper is stiffer and can be folded to make sharper marks and work in tighter spaces, which may be very useful in some sanding jobs. We usually use both types of abrasive sheet, selecting which ever is more suitable for the situation. One paper that is particularly useful because of its stiff backing paper is called production paper.

Here are some simple guides.

- The grade of abrasive should be increased by particle increments of between 30g to 50g. The progression is from 60g, 80g, 120g, 150g and onto 180g and 220g. It is pointless to skip too many grit sizes because it will just take much longer to achieve the same effect.

- If the surface is fairly smooth it is not absolutely essential to begin with 60g. One way to decide which grit to begin with is to try with say 100g. If it takes longer than a couple of minutes to remove blemishes and give an even surface of scratches, then try a coarser paper.

- Make the paper fit the work by using scissors to cut it into sizes that allow you to sand fine detail, rather than having the paper folded into a bulky lump, which will not allow sensitive sanding.

- Cut the paper into strips and then fold it length wise. This gives a sanding tool with a 'safe' edge and a cutting edge which allows for detail sanding.

- It is usually recommended to sand in the direction of the grain, however, sometimes the abrasive cuts more effectively across the grain or at an angle to it. The important thing to bear in mind is that the final sanding strokes of each grade of abrasive are made along the direction of the grain.

HAND SANDING

If the finish of your wood sculpture is going to be smooth, i.e., without any chisel or other cutting tool marks, then this surface will be achieved by sanding. Sanding, when done thoroughly, can take half the overall time that it takes to make the completed sculpture. If sanding is not carried out carefully and thoroughly the result is that 'sore' or slightly blemished areas will show up as dark marks or blotches when the finish coat is applied. It is all too easy to spoil an otherwise good sculpture by poor finishing. If you find sanding boring, try to think positively about the line and form on the piece you are working

on. Sculptors often work on more than one piece of work at one time, so perhaps allowing a rest between sanding sessions while you work on another project could help spread the load. I find that having more than one piece of work in progress at a time allows me to suit the tasks to my mood and energy levels. Hand sanding is a good activity if I am listening to a good radio programme.

In normal use, sanding is carried out by holding the abrasive sheet either as a single sheet or folded into an easily-held pad, where the folded edge can be used to sand in tight areas of the work. Sometimes, by wrapping the sheet around a cork sanding block, more pressure can be applied to the work and help to shape the work to an extent. Further shaping can be done by making shaping sticks. These consist of, as the name implies, lengths of wood that have abrasive paper stuck on with either PVA glue or double-sided tape.

The more usual shapes for sanding sticks are pieces of wooden dowel of various diameters, and square and rectangular sectioned off cuts and wedge shaped pieces of wood.

Another way of using sanding sheets is to fix the whole sheet to a very flat board, e.g, 18mm (¾in.) MDF or plywood either with double-sided tape or preferably glued with PVA glue, and allowed to dry while clamped against another similar board to make sure there are no air bubbles under the surface of the abrasive sheet. Sanding boards are very useful for flattening the base of sculptures. If dust is a problem there is another sanding technique which is to use a lubricant while you are sanding, although it may not always be suitable. Basically, there are two suitable lubricants, water or oil. If water is used it may make the abrasive paper soften and break up more quickly than in normal dry use, although the production papers often are quite tough and I have even washed them when they have become clogged, with no apparent ill effects. Cloth-backed papers are much longer lasting. Water will raise the grain on the wood and the final sanding, once the wood is dry, would need to be made without the water. If oil is to be used, then I use sunflower or cheap cooking oil

(Top) *Sanding sticks, grit sizes marked, diamond impregnated abrasive rasps and below rotary rasps that can be used in a power hand drill.*
(Bottom) *Making sanding sticks by gluing abrasive sheet to dowel with PVA white glue and holding it in place with rubber bands until it has dried.*

(avoid olive oil as it becomes sticky and clogs the paper) as I can be sure that it has no chemicals added which means it is safe to use with bare hands, which is good especially if young people are making wood sculptures. The sculpture can be taken to a final finish with this technique which gives a silky matt finish. As a final finish the sculpture can be wiped thoroughly and given a coat of the oil used as a lubricant or finished in a standard way (see p.64).

POWER SANDING

Power sanding while apparently offering high-speed, effortless results does have some disadvantages which should be considered before you spend your money. Bear in mind that although machines can save a great deal of time, you will almost certainly have to finish the final surface by hand sanding.

Dust (see p.61) has to be collected and although some small hand-held sanders have a collection bag, in my experience these are not very effective. Fine detail may be accidentally obliterated by power sanders which are not so easily controlled as hand sanding. Some timbers scorch easily, especially when power sanders are used in tight and awkward places. The other point to consider about sanders, and this applies to all machinery, is that machines are inherently dangerous. They create noise and vibration and therefore can cause tiredness; they demand absolute concentration from the operator at all times.

Other sanders

Power files. These are basically hand-held, narrow-belt sanding machines. A wide range of grades of abrasive belts is available, so that the tool can remove wood quickly and also produce a fine finish. A very useful tool.

Disc sanders. These can be attached to hand-held power drills, angle grinders and flexible drive tools. They will remove stock quickly but it may be difficult to achieve a good finish because circular sanding marks tend to persist.

Drum or sleeve sanders. These can be obtained in a range of sizes and are held on solid or inflated rubber mandrels. They can be mounted in a number of ways, one of the most useful being on a flexible drive tool or a Dremel.

For the projects in this book hand sanding is generally all that will be required. The best idea is to try to make the first two projects and sand them by hand, as I have done, and then if

you still feel the irresistible need to buy a power sander, you will at least have a better understanding of your requirements.

The effect of sanding, apart from giving a smooth surface to the work, is to dry, crush and compact the wood fibres on the surface of your sculpture. Over a period of time, the fibres gradually reabsorb moisture from the atmosphere, and as a result swell, giving a rough surface where before it seemed smooth. This situation can be improved by wetting the surface of the sculpture while using the latter grades of sanding paper, say 150g or 180g, allowing the wood to dry thoroughly, before progressing to the next grade of paper. The final sanding should not be wetted in this way.

FINISHING

It is a good idea to keep any off cuts from the piece you are making for two reasons. The first is that should you need to repair any part of the work, having wood of the same colour will make any repair less noticeable. Secondly, when you arrive at the finishing stage, test finishes can be experimented with on the off cuts. (See *The Sculptor's Bible* by John Plowman for good ideas on finishes).

Once the final surface of the sculpture is completed to your satisfaction, then you will have to decide how to treat and maintain it. If wood is left raw, i.e., it is not sealed in any way, then it may become discoloured due to being handled and from absorbing dirt from the atmosphere. The choice of which is the best method of sealing the surface is one of individual preference. The two general categories of finishes are **slow drying finishes**, e.g., Danish oil, which are applied over a period of days, and **quicker-drying preparations** that cure or harden more or less in a few hours, e.g., French polish, varnish and paint. There is a vast array of finishing materials and the best idea is to try one or two and see which ones you prefer.

Two tried and tested finishes that can be recommended are:

1 Danish oil (slow drying) – one or two coats of which give a soft lustre to the work. More coats can be applied, each one making the surface glossier.

2 French polish (fast drying) – choose a colourless or pale one, unless you want to give your work a coloured tint.

With all finishing coats try to keep each coat as thin as possible, applying two very thin coats rather than one thick one. A thick, sticky-looking finish may spoil an otherwise attractive sculpture. When the finish has hardened you have the option of adding a wax coat to further enhance the piece. Gently rub the surface with the finest grade of steel wool removing any smears and dust particles, and giving a surface that will hold the wax more effectively. Wax can be applied with cloth, kitchen paper or if the surface is highly detailed, use a 25mm (1in.) paintbrush that you have cut the bristles down on (use scissors) to 25mm (1in.) long to make them stiffer.

Applying finishes

I try to keep the application of finishes as simple as possible. I use disposable surgical-type gloves, which with care last long enough for me to apply several coats of whichever finish I am using. I try to avoid using paint brushes because they need cleaning afterwards and I always worry that if they have been used, they may have traces of previous paint, etc, that may come out of the bristles and affect the surface of the sculpture I am finishing. However, for deeply-cut and gnarled surfaces a brush is the only tool to use and so in that situation I always use a new brush to avoid contamination of the new finish. My usual choice of application method is kitchen or other paper towels because they are cheap and easily available. Do not use coloured and printed types as the print is soluble in oil finishes and colour will bleed onto your work. Guess who found out the hard way! Soft tissue paper is not really suitable as it tends to break up in use. You could use a washed white cotton cloth, but kitchen paper is so easy that it is what I use regularly. Dispose of the used material carefully following the manufacturer's instructions.

OTHER FINISHES

On some occasions you may like to change the colour of the wood you are using; this may be achieved by bleaching it to give a paler colour or staining it to make the wood darker, or you may want to make the surface a more even colour. Due to the nature of wood sculpture, there is a varying amount of side and end grain exposed on a piece and since stains tend to be more readily absorbed by the end grain and this can result in a blotchy surface; again try a test sample first.

If a multi-coloured surface is to be contemplated then coloured pigments in the form of water colours, acrylics and even coloured pencils and crayons can be used to achieve interesting effects. Experiment on your off cuts.

(Left) Man in the moon by Peter Clothier. Pine, sand blasted finish (air abraded). (Right) Three fishes by Peter Clothier. Pine, sanded finish, left raw.

TEXTURE

Do not always assume that a smooth surface is always desirable on wood sculpture. Interesting textures can be used to add to the overall effect on a piece of work. Rugged qualities, hair effects and antique surfaces can be suggested by 'raising' the grain on the surface of a sculpture. In fact what really happens is that the softer grain is scoured out by some means. The most usual is a wire brush, either hand held or one of the rotary types driven by electric drills, flexible drive tools and dremels. Eye protection is essential when using rotary wire brushes.

The other way to raise the grain is by grit blasting or air abrading, the main problem being finding someone with the necessary equipment, but it is worth the effort of looking. Charring with a propane torch just enough to scorch the surface is followed. Wire brushing can give an unusual and surprisingly not unattractive finish. Definitely one to try on the off cuts first!

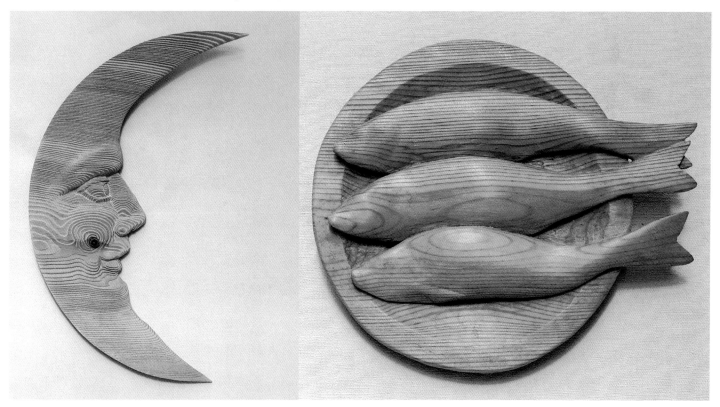

CHAPTER 7

MOUNTING AND PRESENTATION

resentation of the piece is something worth bearing in mind as you are making your sculpture. If the piece is intended to be hand held or wall mounted, then the choice of a base does not necessarily apply, but if the piece is to have a base of any sort then the earlier you begin to think about how you would like to display or mount it, then the sooner the sculpture and base will work as a unit.

One of the most difficult things for any artist to deal with is the manner in which their piece of work is to be presented. For the painter a choice of frame, its size and colour and at what height the painting should hang are some of the elements that have to be considered. It is no less difficult for the sculptor, and a great deal of time and effort can go into deciding the best way to present a sculpture. The choice of base requires a good deal of thought, because it will have a great bearing on the final presence of the piece. Some of the considerations that you may have to deal with are covered below.

The material used for the base will always say something about the piece: marble might suggest a Classical theme, perhaps Greek or Roman. Iron and steel have an industrial connotation and plastic may suggests modern themes. A rough-hewn base or tree root may give a sympathetic quality to a rustic or naturalistic subject. I am sure that you will have ideas of your own about the appropriateness of the material for any given situation.

The colour and surface treatment will also have significance, the more detailed finishes such as polishing and shaping will indicate power-driven equipment and an industrial link. Gilding may suggest wealth and value, and has to be carefully balanced so that it does not overwhelm the sculpture.

Shape and size too will be an important consideration, getting this relationship correct is usually quite a challenge. The delicate balance between stability and too dominant a base can be hard to satisfy.

The height from the ground may have to be set by arranging the work on a plinth or by using some other method to display the sculpture at the desired viewing height. The viewing height of wall mounted works too, will need careful consideration.

The way light falls or is directed onto a sculpture can mean the difference between a powerful image and a disappointing display. Spot lights highlight details and cast strong shadows enhancing form; strip lights deaden shadow and are not usually ideal for displaying sculpture. Outdoor pieces may benefit from early or late sun light, or perhaps may be most effectively sited in front of a wall or foliage. The possibilities are enormous and it is worth considering at least some of the options, after all the effort you will have put into your sculpture.

At the end of each project I have tried to explain why I have used the method of presentation I have used. Of course, this subject is open to all manner of debate, and although we

may not always agree with the way an artist has handled a sculpture or its presentation, by challenging it, we learn more about ourselves and our own values. My own way of questioning a piece I find unsatisfactory, is to ask myself the question, 'What would I change to make this piece of work more satisfactory?' I ask this question about my own work as well as that of other artists. I find this a far more productive response to a piece of work rather than a blanket response of 'I don't like it'!

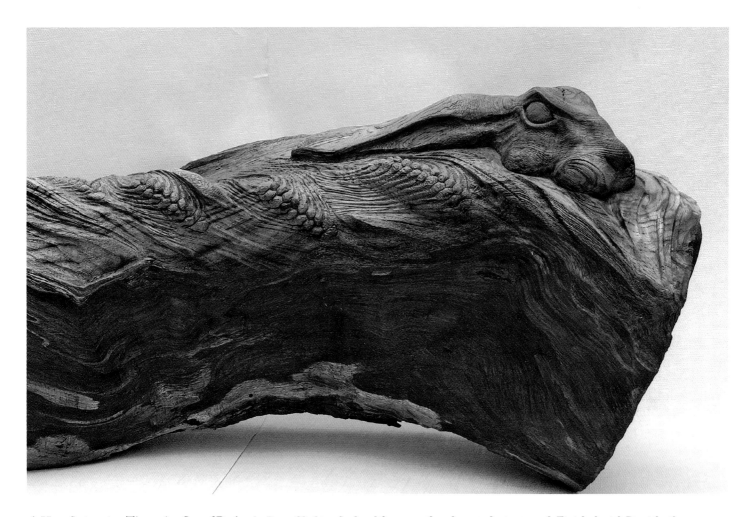

A Hare Swimming Through a Sea of Barley *by Peter Clothier. Sculpted from weathered sweet chestnut wood. Finished with Danish oil.*

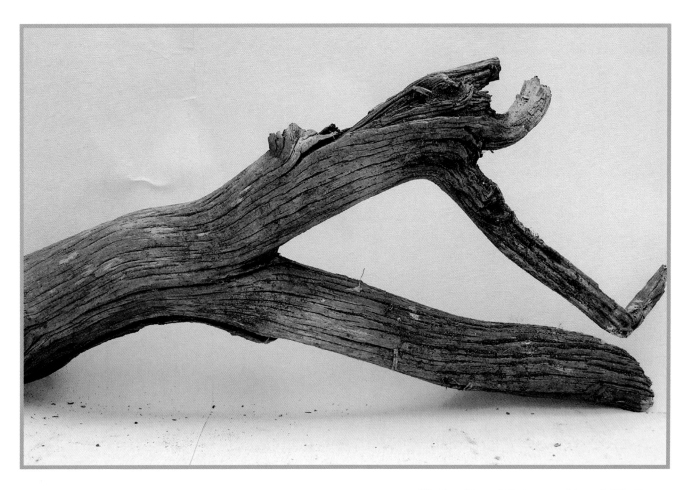

Weathered branch that was used to make The Dancer.

TOOL LIST for THE DANCER

- Hardpoint saw
- Round surform
- wire brush
- Felt tip pen
- 60 grit abrasive paper
- Clamp or vice

PROJECT 1
THE DANCER

This first project requires very few tools – a saw and a surform, some abrasive papers and some way of holding the wood you plan to use, such as a clamp or a vice. The starting point can be either a block of wood from a store or, a branch or root that you have found in the woods, your garden or on the sea shore. The purpose of this project is for you to use your imagination and to work on a piece of wood and just have fun. You may make a bird or a fish, perhaps a figure, or whatever takes your fancy. In the end if it doesn't quite work out, don't worry, just try another piece of wood. It is surprising how even simple shapes, when they have been sanded and varnished, can have a tremendous presence. I sculpted the dancer from an old weathered branch that was lying in our local woods; I think that it is from a sweet chestnut tree. When I began the sculpture I had no idea what I was going to make.

The first thing to do, if you are using found wood, is to brush off all the mud, loose bark and rotted wood, using a wire brush, to get back to sound timber. Now look at the piece of wood from a variety of viewpoints and try to imagine a shape that could be developed. Use the surform to remove any further areas of soft wood until all that is left is sound wood. Look at it again from all sorts of angles; turn it upside down, back to front and any other way that could give you ideas as to how to sculpt the wood.

From the piece of wood in the photo I decided to make

a figure; the fork of the branch looked a bit like a pair of legs, not full-length legs though, but I would deal with that situation later. The other part of the branch looked like a torso with the possibility of making the head and even up-stretched arms, giving the figure a dancing quality.

Bear in mind that this sort of sculpture is not meant to be closely anatomically accurate but is more about representing the spirit of a dancing figure. When you make a piece of sculpture it doesn't have to be like anything in particular, sometimes it is fun just to let the wood and tools take you on an adventure of sculpting and see what happens. Wood is such a wonderful material that you will rarely be disappointed.

Having decided on the general shape, sketch the approximate positions of the head and arms with a pencil or felt tip pen, to give a general guide while you remove the bulk of surplus wood.

Remove all the waste wood indicated by the pencil marks using the surform, constantly shaping and looking for pleasing shapes and lines in the piece.

Next work around the head and up along the arms using the surform, gradually reducing the wood above the head to form the hands and arms. The surform makes fairly coarse cut marks on the surface of the wood, so as soon as you feel that you have worked within a thickness of say 2mm ($\frac{1}{16}$in.) or so of the final shape, begin to use very coarse 60g abrasive paper to remove the tool marks.

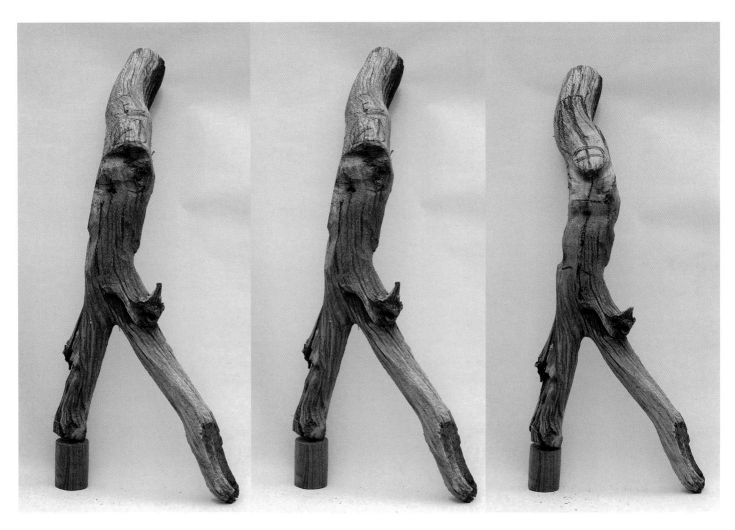

Branch wood wire brushed, soft wood removed with a surform and odd bits removed with a saw, propped against the wall to consider the potential for making a figure.

Branch wood marked in pencil showing approximate position of the head.

The head and arms clearly indicated with clear pen lines. I also indicated the centre line of the body and tried to make sure it had a good curve to it, giving a feeling of movement.

You can also use this abrasive paper for further shaping and softening of the general form, begin to blend all the shapes together. You may see places where you have not taken off enough wood; just go back to using the surform to correct the shape and then continue with the abrasive paper.

In this way you have formed the sculpture. When you feel that the main shapes are how you want them use 100g and 120g production abrasive paper to give the sculpture its final form. When you are satisfied that the piece is finished, a final rub down with 150g abrasive completes the sanding stage.

Two tasks remain; the choice of finish to use and how to present or display your finished sculpture.

Since this is your first sculpture and to keep things simple, use Danish oil to finish the piece. Although it isn't easy to

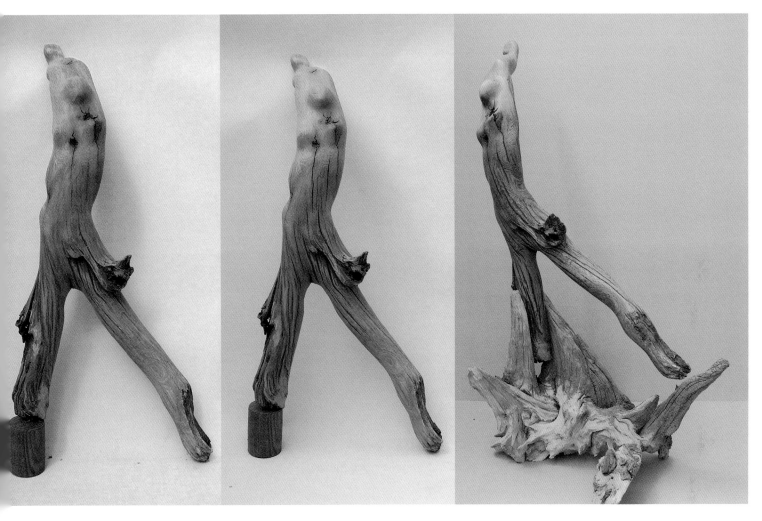

Surform work fairly complete, ready for coarse sanding.

The dancer sanded with 100g paper ready for final sanding and a Danish oil finish.

The finished sculpture, mounted on a sand-blasted tree root.

apply, it is one of the most effective finishes available and the preferred choice of many acclaimed sculptors.

Presenting pieces of sculpture is usually a challenge and with this sculpture I tried to mount the work so that, although the legs are not continuous to the ground, I wanted to give the impression that they were. The base had to be stable enough to prevent the work from toppling over and also to remind the viewer where the dancer was performing. Since it is a very naturalistic piece I searched for a weathered piece of wood and finally I found a partly rotten tree stump, which I sand blasted to clean it but also to give a natural feel to the way the sculpture is presented.

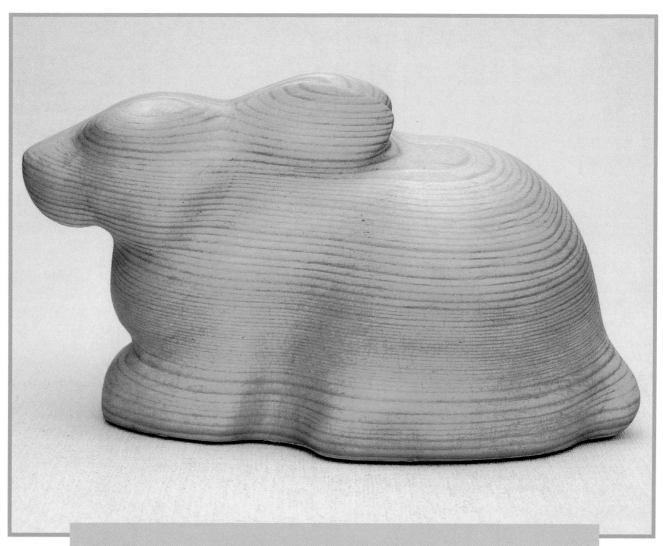

TOOLS LIST for the RABBIT PROJECT

- HB pencil/felt tip pen
- Plasticine
- Try square
- Scissors
- Rule
- Hand saw

- Round surform 1.5cm (¾in.)
- Round rasps 4mm and 6mm
- Riffler 15cm (6in.)
- Abrasives 60g, 100g, 150g and 220g

- White PVA glue
- a small piece of green baize (for the base)
- rubber bands
- A vice – clamped to a bench with 2 G clamps.

PROJECT 2
THE RABBIT

The brief for this second project is a sculpture of a rabbit. It is a simple subject, but do not be deceived, it will require a great deal of care and you will learn about many aspects of the art of sculpture and working with wood. The project will go through all the stages of making a sculpture: the concept, finding information about the subject, making a sketch model, making templates from the model, roughing out, final shaping, sanding, finishing and finally, mounting and presentation.

THE CONCEPT

As well as looking through various books about rabbits, I visited my next door neighbour and took some photographs of her pet, Sparkle the rabbit.

I did not intend to copy the photograph exactly but wanted a reference to give me more information when it came to making my model. I made the sculpture from pine wood, which is commonly used by carpenters in house building and is not expensive. I used the better quality timber, known as joinery grade, which generally has fewer knots. As well as being easy to obtain, it is fairly easy to work and has an attractive grain. It is just as possible to use other kinds of timber – I would recommend lime or jelutong (see the chapter on wood p.29). Try to avoid very hard timbers until you have developed your wood sculpting skills.

I decided to make the rabbit about 15cm (6in.) long and so, with my photographs and other information to hand made the model or maquette.

THE MODEL OR MAQUETTE

Please do try to make your own model; think of making it as a rehearsal for your wood sculpture. Using plasticine, start with the body, moulding it into the general shape of a rabbit. Then model the head and ears as a separate unit and just place it on the body to see if it looks in proportion; it may take a few tries before it looks right. Once you think the shape is correct mould the head onto the body. I wanted to give the model the feel of a quiet rabbit, just resting; I also like the idea of it looking a bit like a jelly mould rabbit.

When you make your model don't worry about the surface being very smooth, but do try to get the general bulk or form correct because you will be making your templates from this model. Concentrate on getting as good an outline or silhouette of the rabbit as possible; try not to make the detail too deep at least for this first project. Although, in the photograph Sparkle's ears are pricked up, I decided that I would make my

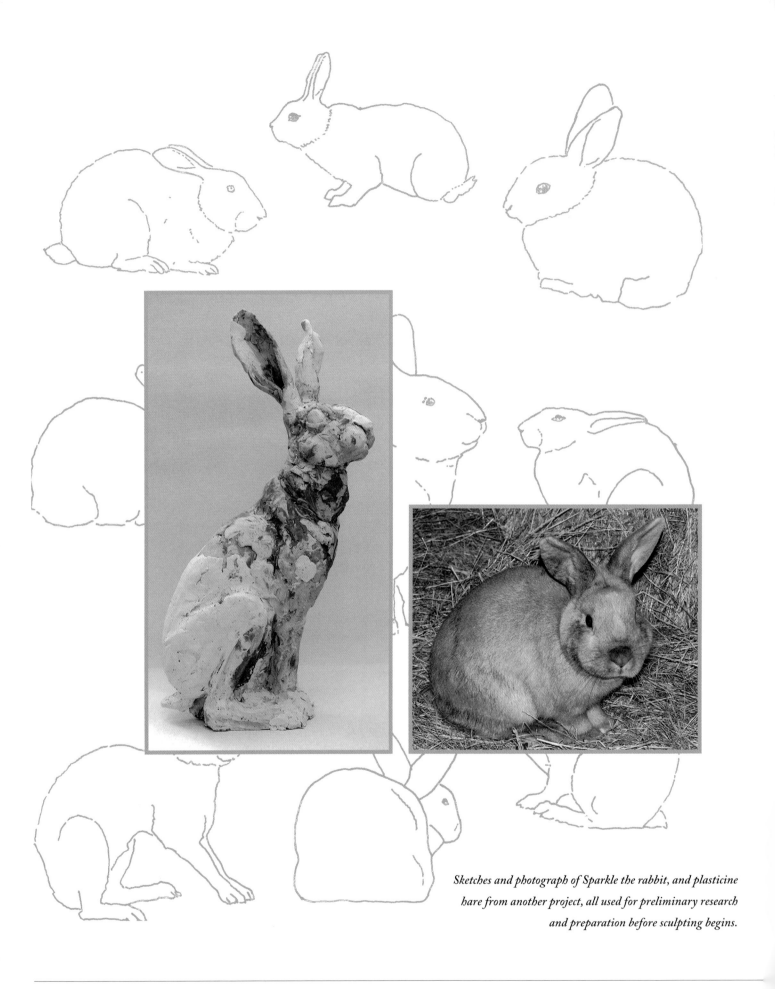

*Sketches and photograph of Sparkle the rabbit, and plasticine
hare from another project, all used for preliminary research
and preparation before sculpting begins.*

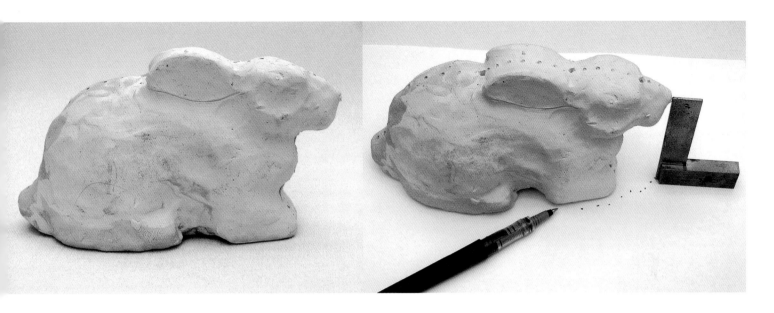

The plasticine maquette of the rabbit.

Plasticine model with the try square in position with marks on the paper showing the method of making the base template.

model with the ears laid back to simplify the pose. If you decide to do yours differently do consider the effects of short grain (see chapter 3). If you do not want to make a rabbit, you could make a cat in a similar pose.

THE TEMPLATES

Using templates makes the identification and then removal of waste wood very much easier. If possible always try to use at least two templates as this cuts down guess work as you reduce the waste wood. The elevations I decided to use are those of the base and the side. The front view would not be very useful and making a template would be difficult.

MAKING THE PLAN ELEVATION TEMPLATE

Stand the model on its base on a sheet of paper on a flat surface. Then, using a try square mark a series of dots about 6mm (¼ in.) apart on the paper, where the try square blade touches the model.

Once the ring of dots is complete, join them up and then cut the template out. This is the base template. The sculpture is symmetrical along the length of the body. As a check that the model and thus template of the rabbit is symmetrical, draw a centre line along the length of the template and then fold it along the centre line. If the two halves are very similar then that is excellent. If the two halves overlap very obviously in different places, then check your model to see what is causing the disparity and if possible correct it and make a new

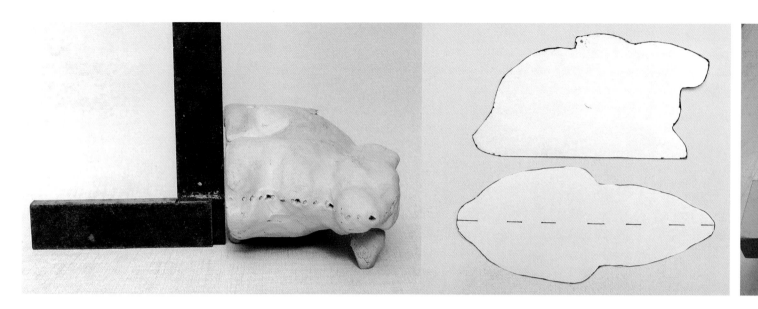

Plasticine model on its side, checked for square to the template paper with a try square.

Side and base templates for the rabbit project.

template, it will only take a few minutes' work. Using the centre line checking method is a very useful technique for problem-solving. If the template is only slightly asymmetrical then you could just make a slight adjustment to it by trimming the two sides together while the template is folded along the centre line.

Making the side elevation template

On a sheet of paper carefully place the model on its side. Use pads of plasticine to support it so that the base is square to the paper (check with a try square). Also make sure that the side is facing directly upwards. As before, use the try square and pencil to make marks every 6mm (¼in.) apart, joining them up; then cut out the resulting shape.

Check that both your templates are the same length, if they are not within 3mm (⅛in.) of each other, double check to see where the error has occurred.

Marking out from the templates

The size of timber to be used on the rabbit project can be selected according to the size of the template you have made from your model or you can use a photocopier to adjust your template size to suit your available timber. My model was 180mm (7in.) long, 100mm (4in.) high and 75mm (3in.) thick. When planning a wood sculpture remember that boards of timber are usually supplied in increments of 25mm (1in.) thickness, so if the exact size of the finished piece is critical, bear this in mind when the model is being made (see chapter

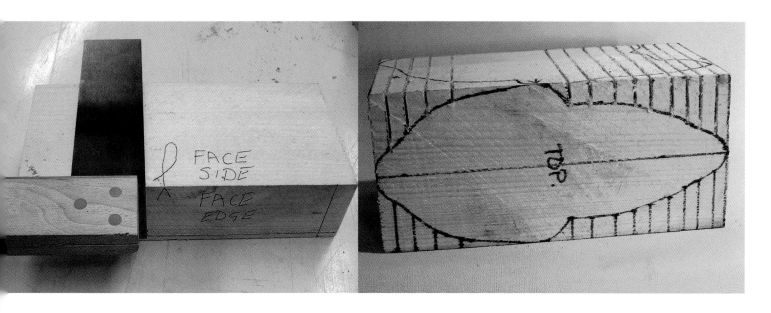

Wood block with templates marked on the plan and side eleva-
tions. They are also marked on the unseen sides

Block showing waste to be removed from base and top elevations.
Saw cuts have been made across the upper lines in the photo.

3). I used a piece of timber 75mm (3in.) thick and the base template was a fairly good fit without much waste. Apply the side template to the wood to make sure that it fits the wood you are going to use before you begin the marking out process.

Registration, or alignment, of templates is critical; the easiest way to ensure that they line up with each other is to cut your wood very slightly longer than the templates. Be sure to use a try square to mark the lines around all the faces of your wood before sawing it to length (see chapter 5, Skills training). Mark centre lines along the long axis of the base, top and ends of the wood; they should all meet. Next mark the base template on the top and base faces of the wood. The centre line on the template must be in line with the centre line marked on the wood. The side template is then orientated so that the front corresponds with the plan template outline.

The ground line of the side template should then be lined up with the bottom edge of the wood block and marked on to the block of wood. Do this on both sides of the wood, making sure that the rabbit faces in the same direction for all the templates.

Roughing out

Wherever possible removing waste wood from the block is best done with a saw, as this is the quickest way. Using a hard point saw make a series of depth saw cuts following the lines you have just marked on the block (see Chapter 5, Skills training).

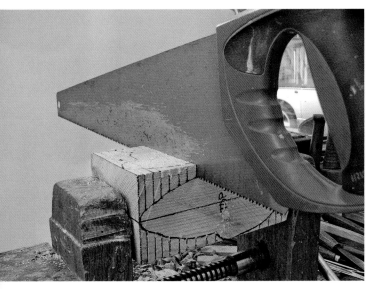

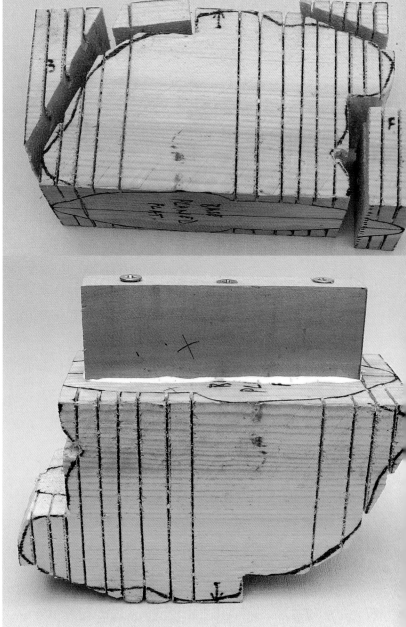

(Above) *Sawing the depth cuts from the top to the base plan view.*

(Above right) *Bulk of wood for the side elevation removed by sawing.*

(Right) *Block fixed to the base of the rabbit.*

Having established these cuts, the next stage is to remove as much waste as possible that shows on the side elevation, using a saw. The reason that we only make depth cuts at this stage is that if we remove all the waste wood according to the base template then it is very difficult to mark out and cut the side profile because the surface left is undulating and it is virtually impossible to draw our template shape accurately.

Once all the wood that can be removed by sawing has been cut off, its time to use other tools to refine the side profile. Use surforms (see Chapter 5, Skills training) and then rasps until the side elevation is shaped back to the template lines. To hold the sculpture more easily fix a block of wood 12.5cm (5in.) long 4cm (1½in.) wide and about 2.5cm (1in.) thick to the base using three screws and PVA glue.

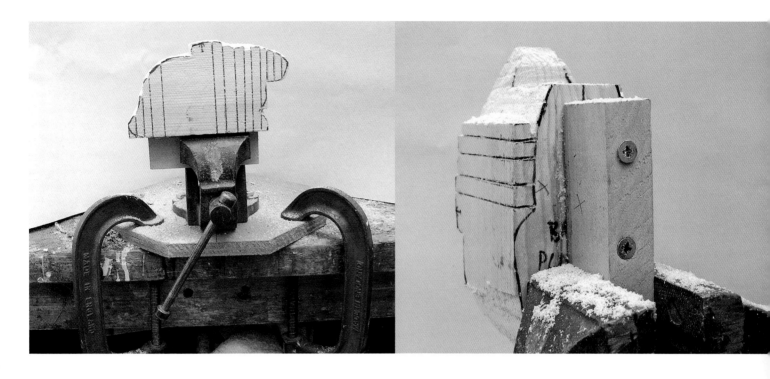

Side elevation completed, sculpture in progress held in the vice by the block of wood. Note the vice bolted to a piece of plywood and held onto the bench top with two G clamps.

Rabbit block held in the vice by the hardwood block showing saw cuts joined by a clear line. Waste wood is being removed from the nose end of the rabbit by sawing.

As you work, check that you have removed all the waste on this elevation and that the adjacent surfaces are at right angles by holding the try square with the stock against the face of the side elevation. The blade should fit flat across the place that you have just sculpted, and just touch the template line on the opposite side. When you have checked that the square fits in this way all around the template line, then you have completed the roughing out of the side elevation.

Now finish roughing in the plan elevation by first cleaning any dust off the newly-sculpted face and then marking a clear line joining all the points at the bottom

of the saw cuts that you made, join the top and base template lines.

Remove as much waste as possible by sawing beside the line at the base of the saw cuts and then, as with the previous elevation, use round surforms and rasps to cut the wood back to the base template line. The face should be square across as before.

Once both plan and side elevations have been shaped back to their respective template outlines the roughing out stage is complete. The next stage is to refine the form of the rabbit.

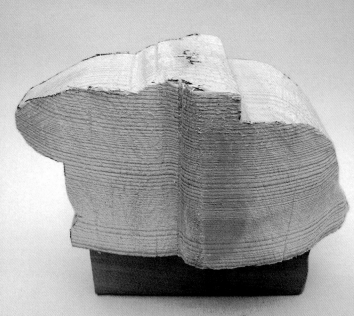

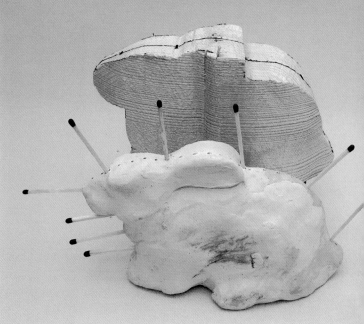

(Above) *Using a surform to shape the plan elevation.*
(Right, top) *Rabbit block at the roughed in stage, with both elevations cleaned up back to the template outlines.*
(Right, bottom) *Model with matchsticks giving datum points to assist with making accurate measurements. The roughed in rabbit behind with corresponding marks along its centre line.*

Refining the shapes

Before you remove any more wood look again at your plasticine model, and from this stage you should constantly refer to it for measurements. For the measurements to be accurate mark a centre line along the roughed out block with a marker pen. Then carefully dot a centre line along the centre of the plasticine model and insert matchsticks, spaced approximately 2.5cm (1in.) apart, along its length. The positions of the matchsticks are then plotted onto the centre line drawn along the length of the roughed out rabbit, transferring the measurements from model to block using your dividers. These datum points are used during sculpting, allowing you to transfer various measurements from your model to the wood, using

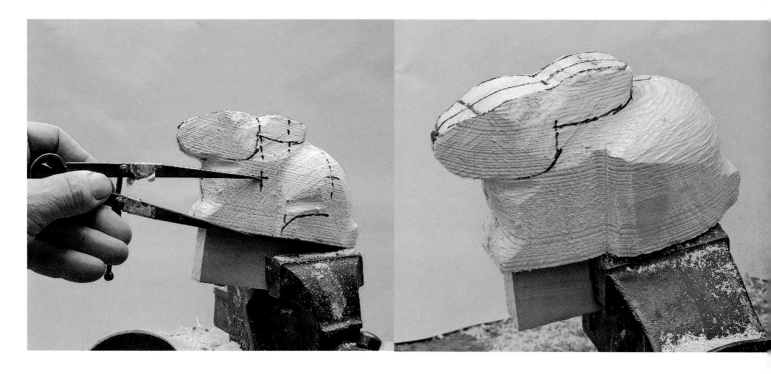

Roughed in block showing marking out using measurements taken from the plasticine model, preparatory to shaping. Measurements being transferred using dividers.

Block after initial shaping with surforms.

dividers and bow-legged callipers.

Measurements are taken from the head and ears of the model and transferred to the wood block. At the same time the position of the tail, front feet and high points of the hips and shoulders are also marked.

Having established these points, remove the waste wood where your marks indicate, constantly referring to the model. If any measuring points, especially the centre line, are removed during sculpting, you should re-mark immediately to keep your measurements accurate. Using a surform, gently round the back of the rabbit, making sure to leave wood for the tail, just cutting close to the lines indicating the ears at this stage. Carefully begin to round the shape under the neck and chest and begin to reveal the front feet.

Next use a smaller tool, a 6mm (¼in.) rat tail rasp, to

further refine the shapes around the nose, ears, tail and front feet.

At this stage you have to be more careful shaping the smaller sections so you don't chip the edges. Once you have removed as much wood as the small 4mm rasp will allow, start to use the riffler; its spatulate shape will allow you to model in the remaining detail on the rabbit.

The one place not shaped yet is between the ears. It is safer to finish the outside of the ears first as sometimes small chips of wood flake off during the final stages of shaping; if the ears are finished on the outside first and there is a flaking problem, there would still be solid wood and the damaged area can be cut back slightly. If the ears had already been carved from the back this would not be possible. Once you have shaped as much of the rabbit as the riffler allows, the next stage is to sand the whole rabbit.

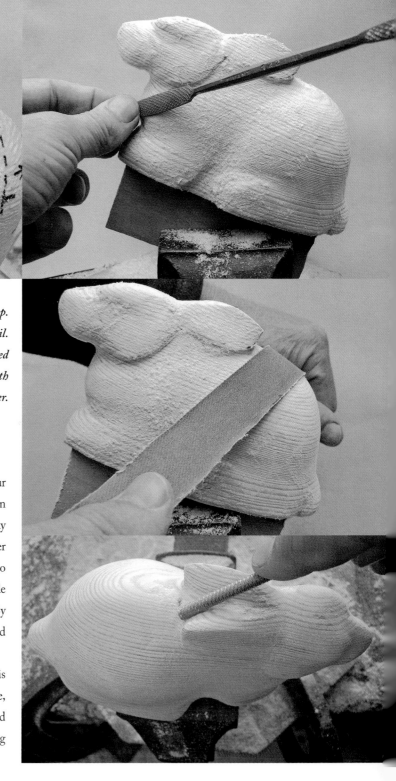

(Above) *Refining head details with a rat tail rasp.*
(Above right) *Using a riffler to shape the final detail.*
(Right, centre & bottom) *Sanding using a cloth-backed abrasive of 100g, after sanding and shaping with 60g production paper.*

Sanding

Sanding can achieve more than just making the surface of your timber free of blemishes. By using very coarse, 60g, production paper not only can you smooth the wood where the riffler may have left a rough surface, but by folding and rolling the paper around wooden dowels you can create a 'tool' that you can use to shape around the detail of the head, particularly the ears, while also smoothing the other areas of the surface of the sculpture. By working in this way, the various shapes of the rabbit are blended into each other, giving the surface the 'soft' feeling of fur.

Once the initial sanding is done, i.e., the whole surface is smooth without any obvious dents or tears on the surface, remove the wood from between the ears using a small rasp and finally 'fairing in' or blending the forms together with the 60g production paper.

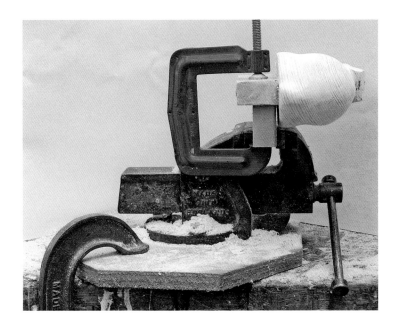

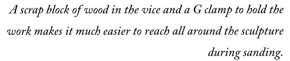

A scrap block of wood in the vice and a G clamp to hold the work makes it much easier to reach all around the sculpture during sanding.

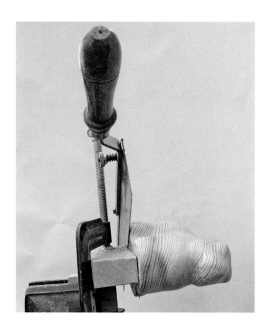

Clamping arrangement for use while sawing off holding block.

Finishing

Having completed the shaping process up to the point where you have used 60 grit production papers to complete the final shaping, next soak the sculpture and then leave it in a cool room to dry completely, preferably overnight. This makes the surface fibres swell and helps to restore any places that have been bruised during sculpting. Sand the surface smooth again but this time with a slightly finer abrasive, 100g. Use a cloth-backed abrasive because it follows the shape of the sculpture more easily and gives a better finish. Be very thorough while sanding, paying particular attention to areas under the head, around the ears and around the tail.

The reason for this attention to detail is that any small blemishes become very much more obvious when the final finish or polish is applied. Having sanded to a high standard, it is time to wet the sculpture again. At this stage take a good long look at your work, not only for the quality of the finish but also for its shape. There is still time to change any detail that is not quite correct, even to the point of re-using the riffler and then working back through the abrasives. Once the rabbit is dry, sand it for the final time, this time using 150g abrasive followed by 220g. When using a coarse-grained timber like pine there is not much benefit using an abrasive paper of a much finer grade, but if you had been working on a harder timber, such as maple, then you would expect to use an abrasive as fine as 600g. Once the surface is satisfactorily sanded remove the holding block by extracting the screws and then sawing through the glue line using a small saw.

Next, clean off any little slivers of wood off the base by flattening it on a sanding board.

Once the base is clean, apply a coat of Danish oil to the sculpted surface and allow it to dry over 24 hours before adding a second coat. (See manufacturer's instructions and chapter 6, Abrasives and finishing.)

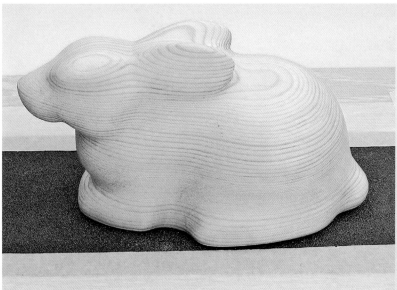

(**Above**) *Flattening the base of the rabbit sculpture on a sanding board.*
(**Top right**) *Pressure applied with rubber bands to press the base of the rabbit firmly to the board while the glued baize dries.*
(**Right**) *A file being used to trim baize on the base of the rabbit.*

Leave the rabbit to dry for a further 24 hours, and then gently rub the surface with fine grade steel wool before giving the rabbit a final coat of oil. Leave the sculpture for several days to allow the oiled surface to harden thoroughly. The final process is to stick green baize on the base of the sculpture. Give the base a light rub on the sanding board, to remove any oil finish that may have run there when you were polishing the rabbit, and then apply a thin layer of PVA glue to the base. Cut a piece of baize, 10mm (½ in.) larger than the base and stick it onto the base, holding the pressure on it using a small flat board with elastic bands. Make sure that you put a piece of newspaper between the baize and the board, so that if by chance any glue seeped through the baize it would be absorbed by the paper.

Once the glue has dried thoroughly the baize can be trimmed by stroking around the perimeter of the base with a fine file at an angle of 45 degrees. This cuts through the baize leaving a very clean trimmed edge.

Once the overlapping part of the baize is removed the sculpture is finished.

I hope you have followed the process, but if you found any difficulties then please refer to the appropriate chapters.

A variety of rabbits and hares (some unfinished) sculpted in wood, including (right) a rabbit head walking stick handle. All by Peter Clothier. The finished rabbit made in the project is illustrated at the start on p. 72.

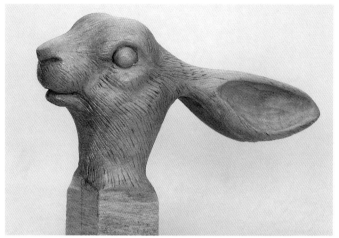

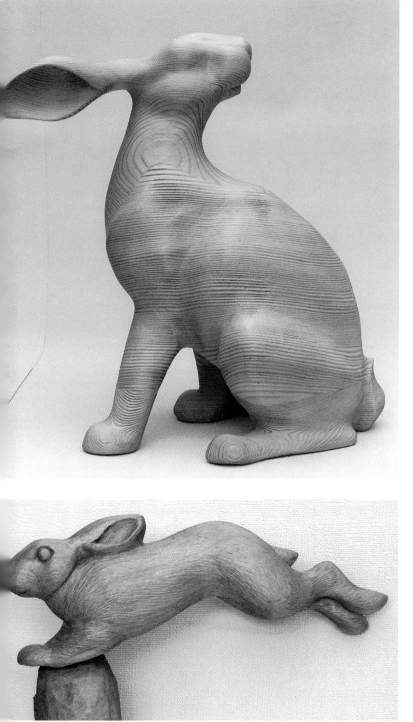

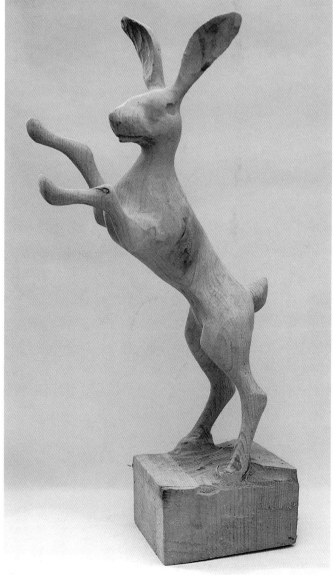

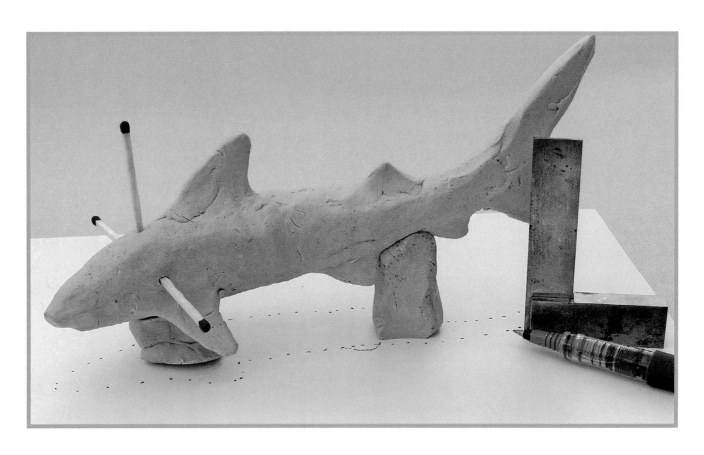

Shark model supported on pads of plasticine. Note the matchsticks used to ensure the 90 degree orientation when making the side elevation template.

TOOLS LIST for the SHARK PROJECT

- Felt tip pen
- Try square
- Panel hardpoint saw
- Coping saw
- Round surform
- Riffler

- Rasp
- 60g abrasive paper
- Abrasive papers up to 220g
- Vice & soft jaws
- G clamps

PROJECT 3
THE SHARK

This project has been designed to show how to work with a subject that has no base or obvious way by which it can be held during sculpting. When a subject with delicate parts such as fins is being made, it is important to work out the best way not only to hold the piece during sculpting, but also the sequence in which each element of the work is developed.

In deciding on a subject for this project I found it difficult to choose between sharks and dolphins (you can really use either, the process is the same), but as I have always been impressed by sharks, their apparent ease of movement and amazing speed, I decided on a shark.

Start your research by looking on the internet for background pictures and information. You can also try books and wildlife magazines. I discovered that there is a huge number of species with many interesting evolutionary modifications such as the curious hammerhead shark.

A selection of shark images traced from pictures from books and the web.

The next stage is to make a maquette of a shark. Having made the plasticine model try various positions and body movements by manipulating it until you really get the feeling of movement made by a shark. (My maquette was 20cm/8 in. long.)

As before, the next stage is to make the templates. Because the shark model does not have a flat base, the problem arises of how to ensure that the two elevations are exactly at right angles. To make the plan elevation template I set up the model on pads of plasticine (see photo opposite).

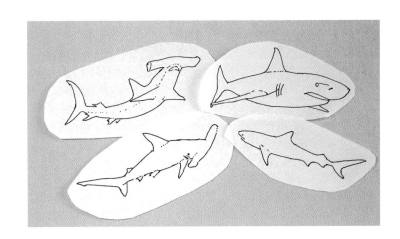

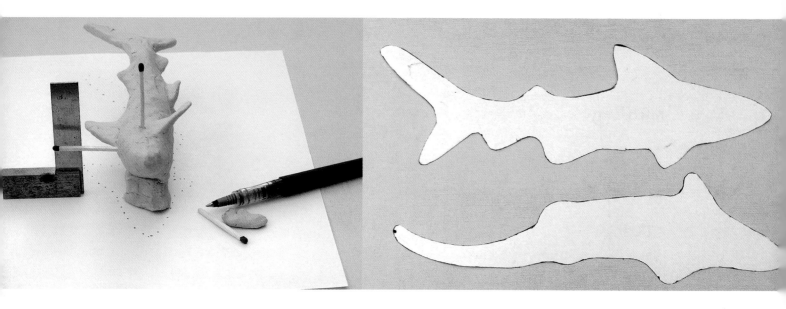

Making a side elevation template using the try square.

Shark templates. (Above) side elevation, (below) plan elevation.

Using the square and pen plot the template. To make the side elevation template, rotate the model through 90 degrees. Again, by propping the model on pads of plasticine and ensuring that the previously horizontal matchstick was perpendicular, plot the side elevation. Cut out the resulting templates and if appropriate, enlarge them to fit the wood available, using a photocopier (the final size of my sculpture was 30cm/12in.).

Don't forget to make your scale rod while you are enlarging your templates on the photocopier. (See chapter 2, pp.17–21). The wood I used was 7.5cm (3in.) thick.

Notice how the tips of the nose and ends of the tail line up exactly on each face with the lines squared around on the ends of the block of wood.

One question that must always be carefully considered is how will the piece of work be gripped during the sculpting process? For this project opt for a small block of wood glued and screwed into the waste wood of the base of the shark block for extra strength. This will hold the work while the top and sides are shaped, allowing you to complete the bulk of the sculpture, and will be removed when you are ready to finish the belly and pelvic fins. After removing the block, the work should be gripped using soft jaws (see p.32) in the vice to avoid damaging the sanded upper parts of the shark.

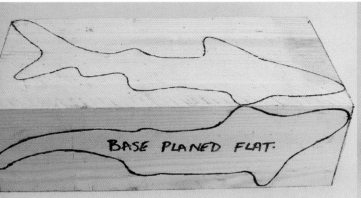
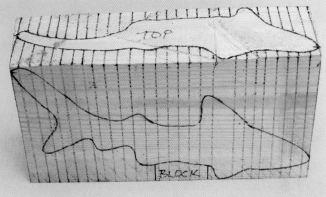

(Above) *The block of wood with base and side template outlines marked with felt tip pen.*
(Above right) *Block marked ready for depth cut sawing.*
(Right) *Cutting depth cuts with a hardpoint saw. Each line was cut in this way all around the block. Notice the work cramped firmly to make it more stable during sawing.*

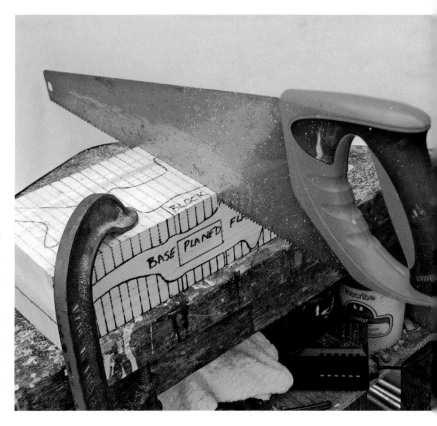

Once the templates are marked to show where the waste wood from each elevation can be removed, using a try square, mark a series of lines about 1.5cm (⅜in.) apart across the side elevation but leaving the base and top plan elevations clear.

Make depth cuts using a hardpoint panel saw, taking very great care not to over run the cuts into the plan elevation area (on the top and base of the block). The saw cuts should be made from both sides of the block to ensure that you do not make a mistake by over cutting.

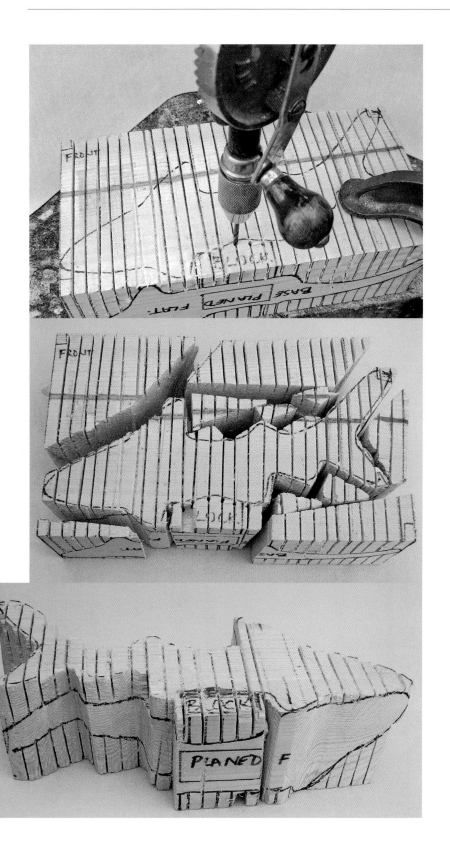

(Top left) *Drilling template line marking holes to help identify the outline when the base block is removed. The position of the holding block is marked with pen.*
(Middle left) *Side elevation with off cuts produced by sawing around the outline.*
(Bottom left) *Plan elevation indicated by depth cuts marked with felt pen.*

Because it is not possible to cut out the outline where the base block is to be attached, mark the position of the template line with a series of drilled holes, 0.3cm (⅛in.) at approximately 1.5cm (⅜in.) apart, as above.

The next stage is to cut around the side elevation shape with a hand saw, using a series of cuts that removes small off cuts.

Once as much of the waste as possible has been removed, the remaining waste is shaped back to the side profile line using a round surform. Brush the wood dust off and the position of the depth saw cuts made earlier can be seen; join these up with a felt tip pen to show the plan elevation.

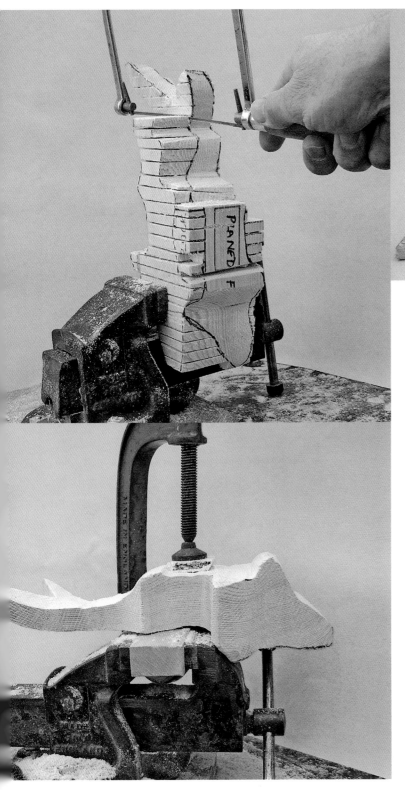

(Top, left) *Using a coping saw to remove the waste wood from the tail of the shark.*

(Bottom, left) *Shark block held by cramping it to a spare block of wood held in the vice.*

(Above) *Holding block glued and screwed to the waste wood on the base of the roughed in shark.*

The next stage is to remove the waste wood indicated with a panel saw and for the curved shapes, the coping saw.

Because you are working with a delicate shape, first saw off the tail waste gripping the block of wood in the vice. Using a surform, shape the tail back to the line. That done, remove the remaining waste from the head end and finally, again using the surforms, reduce the waste back to the line.

The next step is to glue and screw the holding block to the base of the roughed in shark block. Leave it overnight to make sure the glue has dried thoroughly.

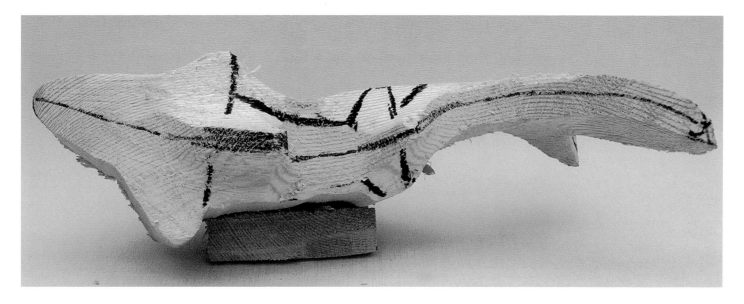

Top view of roughed in shark showing preliminary marking of centre line, fins, etc.

Opposite

(Top) *Initial shaping of the shark body using a round surform.*
(Middle) *Bulk of waste wood removed using the round surform.*
(Bottom) *The shark is now shaped using small rasps and rifflers and ready for sanding.*

Referring to the plasticine model, mark on the centre line and position of the body and fins.

Once the marking out is resolved start shaping the shark's body using a round surform.

Start by removing wood from each side of the dorsal fin and shaping the body. Make sure that the centre line is replaced if it is removed during shaping. Measurements are taken, using the scale rod, to check which areas of wood need removing. The top of the shark is shaped in this way using just the round surform.

The surform is an incredibly versatile and useful tool, with replaceable blades, but care must be taken as the coarseness of cut made by the surform does tear the wood, and so the final shaping is best done with a rasp and finally a riffler.

After riffling the surface, sand the shaped area with 60g production abrasive, which is very coarse and can also be used to make small adjustments to the shape.

So far we have worked as much as possible on the top of the shark; next we will begin to shape round under the head and round the tail and anal fin, shaping carefully around the more vulnerable areas.

Use sanding sticks and rifflers to correct the shapes, give all the shaped surfaces a good sanding and then thoroughly wet the sculpture, leaving it to dry overnight. This raises the grain and shows up tears and dents on the surface caused by the surforms and rifflers. Sand the surface again with the 60g followed by 120g abrasive paper. Try to finish as much of the shark as possible while it is still attached to the holding block.

The next stage is to begin to work more intensively around the area where the holding block is fixed to the shark; do this using a small rasp.

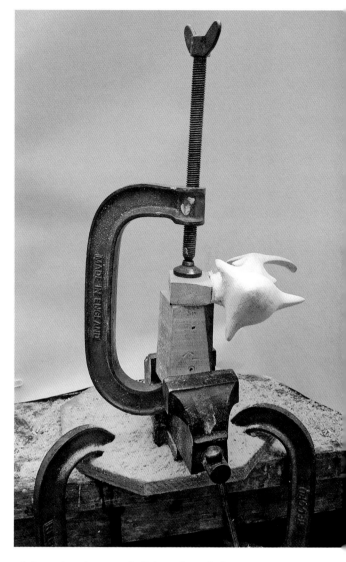

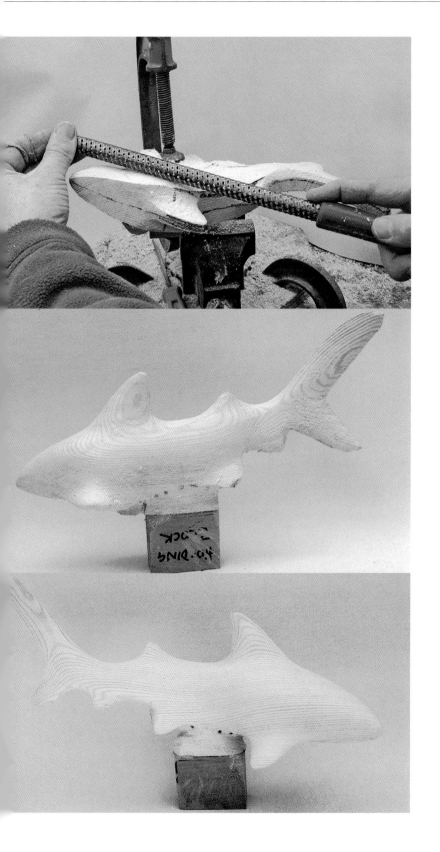

It is much easier to sand all the awkward places on the shark if it is clamped to a spare block of wood which is held in the vice.

Cutting off the holding block using a coping saw.

Cleaning up between the fins with a riffler after the holding block was removed.

Next comes the tricky stage! Holding the shark's body in the soft jaws, tidy up the saw cut area using rasps and a riffler followed by a final shaping with 60g abrasive paper.

As before, once sanding is finished, soak the shark and leave it to dry overnight. Then after sanding with 60g and 120g abrasive paper, a final soaking and then when dry the whole shark is sanded with150g and then finally 220g abrasive paper to give the surface a smooth finish.

Finish the shark using pale French polish, applied with a soft brush (kitchen paper would stick). It is very important to apply the polish using very thin coats and allow at least 24 hours between coats. The number of coats applied will depend on the absorbency of the wood. My preferred method is to gently smooth the polished surface, with fine steel wool, after the second and third coats. Steel wool will remove any dust particles and helps to make a better surface key for the next coat of polish. I have found that three coats of polish are usually enough, any more than that tends to make the work too glossy; however, if the piece demands a high shine more coats may well be appropriate. The purpose of the French polish is to seal the surface of the wood in order to provide a hard layer to give a base to support the wax polish layer. If the wood is not sealed, wax polish will soak into the wood and it will be more difficult to achieve the soft shine associated with a wax polish finish. Allow at least 24 hours for the final coat of French polish to harden and then using fine wire wool carefully but thoroughly soften the polished surface until it is evenly dulled. This removes any dust and nibs from the surface and gives a keyed surface for the wax polish. There are wax polishes available that the manufacturers suggest do not require a previous sealing coat. They can be useful for quick results, however I tend to favour the slower method described above as it allows me to adjust the finish appropriate to the piece.

PRESENTATION AND MOUNTING

I wanted the shark to appear to be diving slightly in order to give an extra feeling of movement so I mounted it head pointing downwards at an angle.

Since this sculpted shark is derived from a reef shark I wanted the base to reflect the appropriate habitat, so I looked for some driftwood that suggested reefs and the underwater

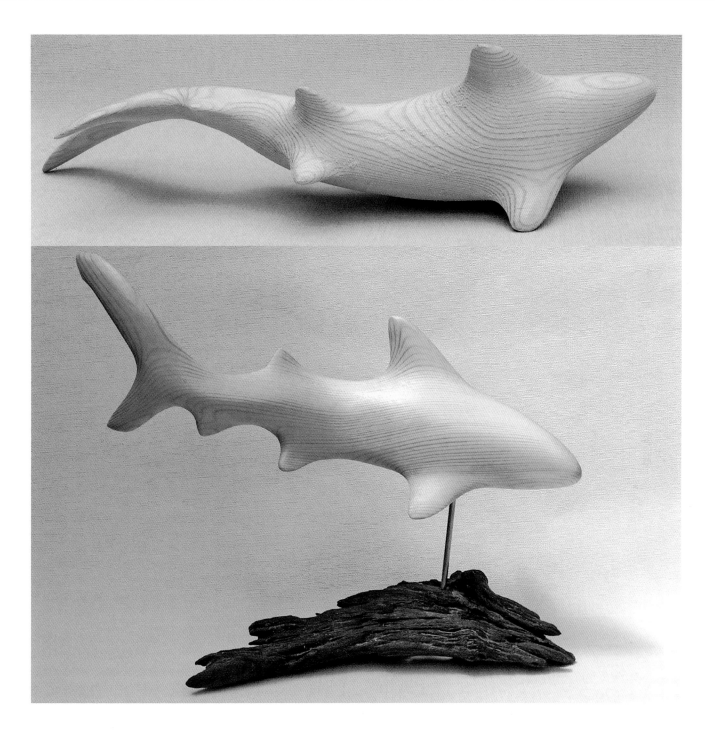

environment. I kept the mounting pin to a minimum to give the impression of the shark just skimming over a coral reef. The base was left without any finish to keep the driftwood feel, reminding the observer of the sea.

(Top) *The underneath of the shark having been riffled to shape, ready to be sanded.*
(Above) *The finished shark.*

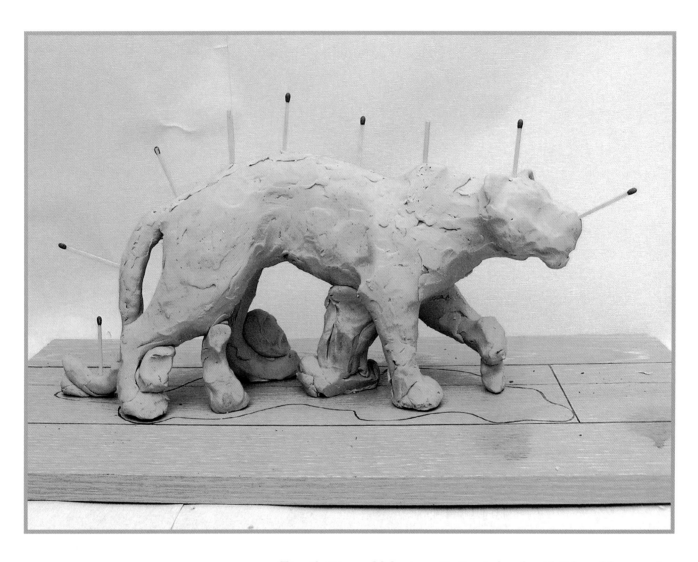

Tiger plasticine model showing supporting pads and matchsticks used for measuring.

PROJECT 4
THE TIGER

When you make a wood sculpture there is no absolutely correct way to work, providing the safety aspects are fully considered. In this project I have compared two different ways of working, in order to give you some ideas about the different techniques that you can use when you are making a piece of work. In one, power tools have been introduced. The pine tiger is made using chisels, rasps and rifflers up to the sanding stage whereas the plywood tiger is made using power tools, namely a flexible shaft tool with various burrs and other attachments. The techniques are interchangeable; the only point to mention is that plywood, because it is made with hard glue, will blunt chisels very quickly. I chose plywood and pine so that the stripes formed by the laminations and grain of the wood would give the impression of the tiger's natural markings. In order to show different ways of making the original rough out I made the pine tiger with a base and the plywood tiger free standing.

TIGER – BOTH PLYWOOD AND PINE VERSIONS

Tools needed for the tiger projects – general

- Vice with soft jaws
- G clamps
- Callipers
- Abrasive papers
- Cloth backed abrasive bands
- Hardpoint handsaw
- Optional Power Tools
- Band saw
- Portable dust extractor
- Hot glue gun or wood screws

<table>
<tr><td>

Tools for pine tiger (hand tool project)

- Woodcarving chisels

 - ¾ in. (18mm) or ½ in. (12mm) cut#8

 - ¾ in. (18mm) or ½ in. (12mm) cut#3

 - ½ in. cut#5

- Rifflers 20cm (8in.) coarse and 15cm (6in.) fine cut

- Danish oil - optional

NB: Follow project on left hand pages

</td><td>

Tools for plywood tiger (power tools project)

- Flexible shaft drive machine e. g. Foredom

- Various burrs – Kutzall coarse and fine to suit
 the machine and size of sculpture

- Portable dust extractor

- French polish and wax –optional

- Material for base

NB: Follow project on right hand pages

</td></tr>
</table>

(Opposite, above left) *tiger maquette showing the use of the try-square to plot the plan view template.*

(Above right) *Check the model is at right angles to the paper with a try square. Note the pads of plasticine keeping the model in the correct position and the matchsticks confirming the correct position.*

(Below) *The completed tiger templates.*

Making model and templates

As with previous projects, do research for images of tigers in books, magazines and on the web and then make your model.

The next stage is to make templates from the model in order to transfer the profiles on to your block of wood (preparing the plywood block is explained later). The model may sag so use pads of plasticine to keep its shape while you plot the outline.

For this project a plan view, i.e. looking down from above and a side profile, will give the best options for templating. Place the model on the sheet of paper and using the try square and pen, plot the outline of the plan of the model onto the paper.

Plotting the template for the side elevation needs more care, as you will have to make sure the feet of the model are exactly at right angles to the paper; check this with a try-square.

Support the model in the correct position using pads of plasticine. Double check that all is correctly positioned, then plot the side profile and join up the plot points; cut around the outlines on the two sheets of paper to produce the plan and side templates.

If necessary enlarge the templates on a photocopier and do not forget to make a scale stick (see p.20) at the same time. The tigers illustrated are the same size; 34.5cm (13½in.) long, 14cm (5½ in.) high and 10cm (4 in.) wide. The pine block also needs extra wood for the base. (I allowed 2.5cm/1in. so add that to your calculations for the original block). If you are band sawing the shapes read the section below about allowing extra length on the block to make band sawing easier.

The pine tiger is made using edge tools, rifflers and abrasives and the plywood version solely with flexible drive tools and abrasives.

NB: Please make sure you are safe to use the power tools used in the plywood project or at least work under supervision.

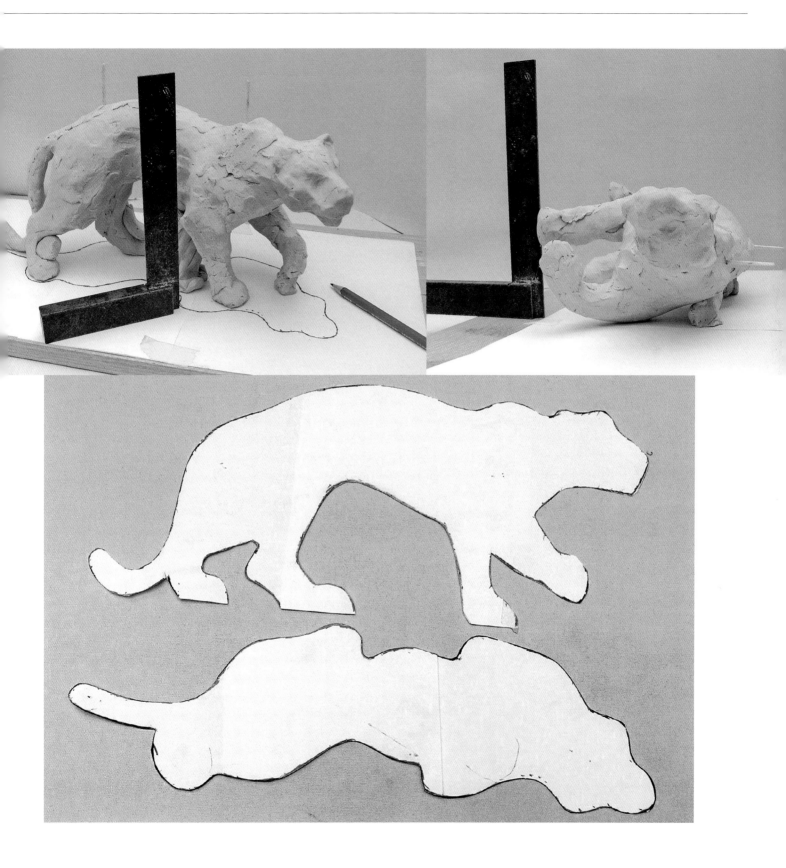

PINE TIGER –
USING CHISELS, RASPS AND RIFFLERS

Preparing the block

The pine block just needs to be cut to the correct overall size. Try to make your original block at least 5cm (2in.) longer than your side template, 2.5cm (1in.) each end and at least 1.2cm (½in.) wider than the plan template. This will make cutting out the two profiles much easier if you are using a band saw (see below). If you are using a handsaw then use the techniques described in the rabbit and shark projects.

The pine block with templates marked out. Note the raised front paw is supported by a temporary bridge of wood to give support to the vulnerable short grain of the leg. It will be removed at the last possible stage.

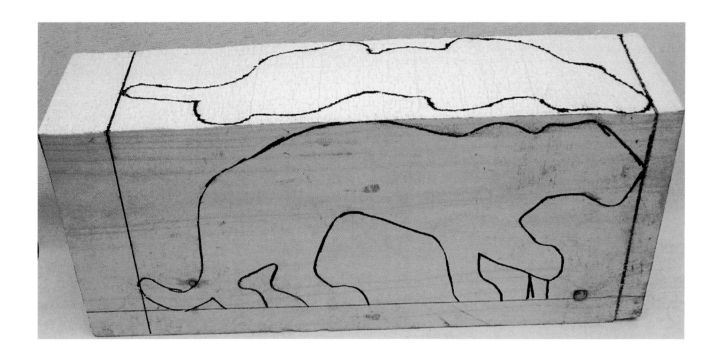

PLYWOOD TIGER –
USING POWER TOOLS

NB: *Please make sure you are safe to use the power tools used in the plywood project or at least work under supervision.*

Preparing the block

The plywood block has to be made by gluing pieces of plywood that have been cut to the size of the required block (see below for size considerations). The laminations must be in the vertical plane in order for the stripes to be effective in the finished sculpture. I used some recycled marine plywood for this project; most plywoods would be suitable but some cheap ones do tend to have small voids between the layers that might affect the finished work. (Check the cut edge to see if the laminations are continuous.)

The thickness of the plywood you use is not critical but it makes life easier if it is about 1.8cm (¾in.) thick. The number of pieces you will need depends on the thickness of the plywood and how thick your blank needs to be; you can calculate this from your plan template.

Try to make your original block at least 5cm (2in.) longer than your side template, 2.5cm (1in.) each end and at least 1.2cm (½ in.) wider than the plan template. This will make cutting out the two profiles much easier if you are using a band saw (see below). If you are using a handsaw then use the techniques described in the rabbit and shark projects.

To work out the number of sheets of plywood needed to make up the block draw parallel lines the thickness of the available ply apart and place the plan template on top. Be generous to make the band sawing easier.

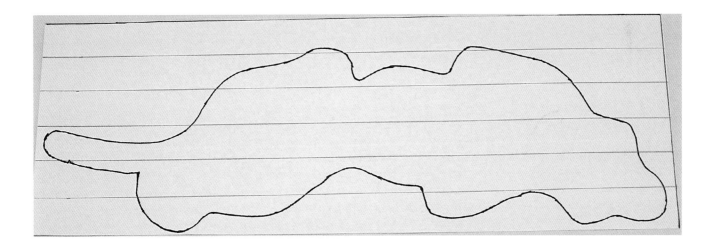

PINE TIGER – USING CHISELS, RASPS AND RIFFLERS

Marking out the block

It is most important to line up your templates (see registration, p.77) so that the tips of the nose and tail touch the line you have marked around at each end of the block, using your try square and pencil.

Mark out the plan profile on the top of the block and the side elevation on both the sides of the block. You will be chiselling from both faces when the area between the legs is cut out. Make sure that the ends of the templates all touch the squared around lines on your block and that you have marked a ground line where tiger's feet stand on the base.

When you have marked out the profiles with your templates, indicate the waste wood with parallel diagonal lines.

(Top) *Pine version; the plan view with holes drilled around the outline.*

(Bottom) *Pine tiger block after drilling. Notice the drill holes by the tail and under the neck. These holes are quick to make and make turning the work during band sawing much easier.*

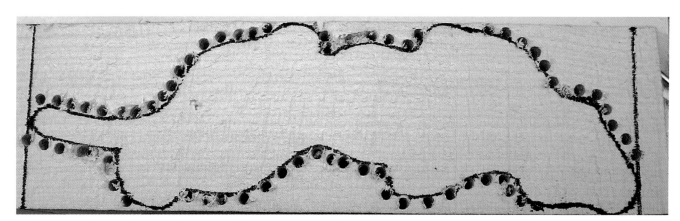

Using PVA glue and plenty of G clamps, stick the sheets of plywood together to create the final block. There should be an even squeeze of glue along the glue line. It is easier to glue the sheet together in pairs first and then glue those elements together to make the final block. Try to keep the base of the block flat when you glue up. After the glue is thoroughly dry scrape off any dry excess and make the bottom of the block as flat as possible.

Marking out the block

It is most important to line up your templates (see registration, p.77) so that the tips of the nose and tail touch the line you have marked around at each end of the block, using your try square and pencil. When you have marked out the profiles with your templates, indicate the waste wood with parallel diagonal lines.

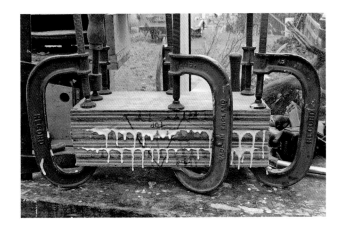

(Left) *Plywood block glued and held until dry with G clamps.*

(Below) *Plywood block marked with plan and side elevation template profiles, the waste marked with blue diagonal hatching.*

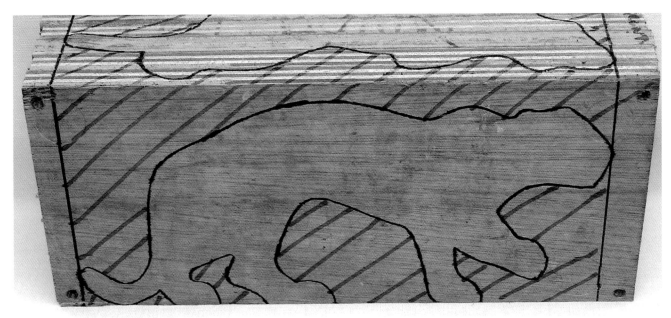

Making the rough out

Preparing the pine block is more complicated than the simple two elevation sawing technique used on the plywood version because of the integral base. The techniques used here, once understood, will enable you to attempt more complicated sculptures as your progress develops.

The pine tiger is made from a block of wood that also includes the base of the sculpture. This means that conventional two elevation band sawing techniques cannot be used. There are also trapped shapes between the legs which cannot be removed by sawing. Because there is to be a base on this sculpture, band sawing the plan outline is not possible so in order to establish the plan outline, drill a series of holes, 1cm (⅜in.) about 1.2cm (½in.) about 2cm (¾in.) apart following the plan outline on the waste side of the line. It is essential that the holes are perpendicular in order to keep the plan shape accurate.

The best method is to use a drill, to make the initial holes about 7.5cm (3in.) deep, and then extend those holes with a hand drill and bit that will reach down to a point just above the base of the sculpture. Turn the block so that the side elevation is uppermost and use the drill to make a series of holes in the waste wood around the trapped space between the legs. Use a larger drill to clear the bulk of the waste in the trapped shape.

This will not only identify which is waste wood when the marked outline is removed during sawing, but makes it much easier to remove the remaining waste wood.

Cut around the side elevation shape with a band saw or hand saws. Remove the wood from between the legs with a 1.8cm (¾in.) or 1.2cm (½in.) cut #8 gouge, and a 1.8cm (¾in.) cut #3 sweep and mallet. It is easier if the wood is clamped to the bench top for this stage to give more support to the work. You may find a smaller gouge helpful to get into the tighter curved shapes. Cut from both sides of the block, check that you have cut a clean face by using a small steel rule which should be fairly flat on the cut face and touch the template outline on both side elevations.

Screw a length of timber (5 x 5cm/2 x 2in.) to the base of the sculpture in order to be able to grip the work in the vice.

(Below, left) *The pine tiger with the side elevation cut with a band saw. The trapped shape between the legs outlined with drill holes; the bulk of the waste removed with larger drills. The plan outlined by drill holes can be seen on the cut surface.*
(Below, right) *The space between the legs cleaned out. The waste on the plan elevation is marked and the temporary bridge of wood supporting the front left paw indicated with blue pen.*

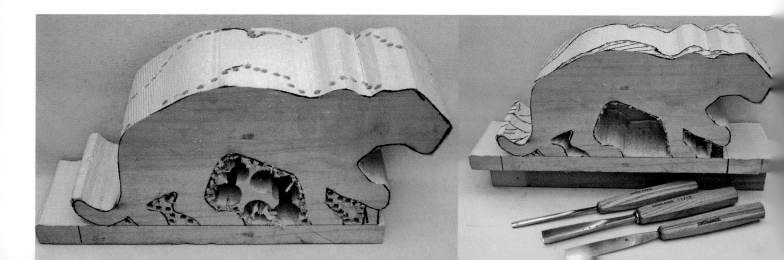

PLYWOOD TIGER – USING POWER TOOLS

Making the rough out

The plywood tiger is cut out using a band saw. (Alternatively you can use a hardpoint handsaw and coping saw, in which case the side templates will have to be marked on opposite faces of the block as you did in the rabbit project.)

In order to remove as much of the waste as possible it is desirable to cut out both elevations using the band saw. Saw the plan elevation first. Cut off a slice that is marked with the side elevation in one piece and this can be fixed back on the block later, either with screws or hot melt glue (using a hot glue gun),

when you cut the side elevation. The extra length of wood that you allowed on the original block will allow you to leave two 'legs' on the side opposite to where the first slice was cut off.

Remove all the waste wood apart from small bridges of wood that keep the 'legs' in place, by the nose and tail. Then reaffix the side elevation slice back in place with a hot glue gun or wood screws. Turn the block so that the side elevation face is now on top and saw around the outline but avoid the 'legs,' which keep the whole job steady.

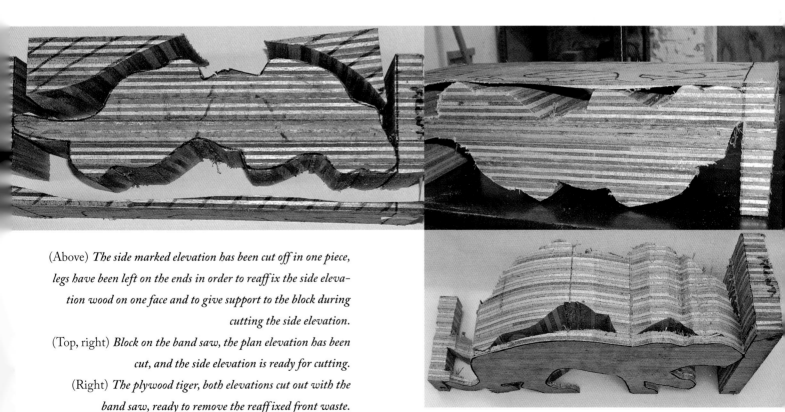

(Above) *The side marked elevation has been cut off in one piece, legs have been left on the ends in order to reaffix the side elevation wood on one face and to give support to the block during cutting the side elevation.*
(Top, right) *Block on the band saw, the plan elevation has been cut, and the side elevation is ready for cutting.*
(Right) *The plywood tiger, both elevations cut out with the band saw, ready to remove the reaffixed front waste.*

The next stage is to remove unwanted wood from the plan elevation. Using the same tools chisel off the waste, so that the drill holes are just removed and the plan outline is revealed.

Refining the rough out

The next stage is to mark out the legs on each side of the roughed out pine or plywood block, clearly indicating the waste wood with pen or pencil lines.

This is a good time to mark out the centre line and any datum points, needed for measuring, that you have indicated on your model (for method see p. 80).

Hold your work in a vice or on a bench with G clamps; remove the waste wood you have marked using the mallet and chisels as before. Take small cuts and only remove wood back to where the centre line would run through the wood; this will allow you to shape the outside of the legs more easily at the shaping stage (see below). Try to keep your finished cuts at right angles to the line you are cutting to, as this will help to keep your overall shape accurate when the legs are released from the block as the overall shaping begins.

Pine rough out with leg positions indicated with black pen. The centre line is also marked.

Reverse views of pine tiger showing marking out of the legs and indicating the waste wood to be removed.

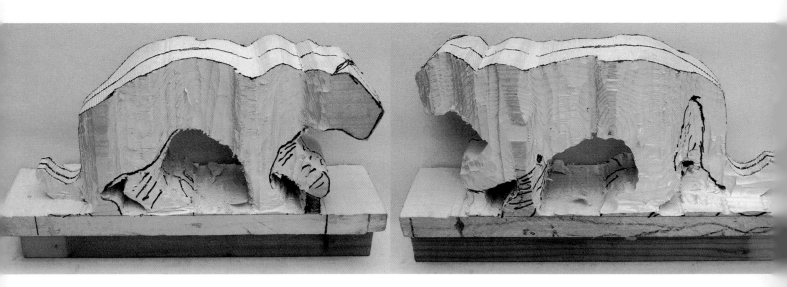

The last band saw cut is to remove the wood behind the tail. The extra legs are finally removed using a handsaw; band sawing any further would be dangerous. The rough out is now ready for marking out the leg positions.

Refining the rough out

The next stage is to mark out the legs on each side of the roughed out pine or plywood block, clearly indicating the waste wood with pen or pencil lines.

This is a good time to mark out the centre line and any datum points, needed for measuring, that you have indicated on your model (for method see p. 80).

The waste wood that you have marked can now be removed using the flexible shaft tool. Mine is made by Foredom (see suppliers); I used an 'extreme kutzall' burr, the coarse grade. It is important in the early stages of roughing out with this burr that you hold the work steady, preferably in the vice using soft jaws, while you get used to the cutting action. If you are inexperienced with flexible shaft work, start by using a 1.25cm (½ in.) burr until you get the feel of the tool. Support the hand holding the hand piece of the tool by keeping your thumb firmly pressed against the work and draw the cutter slowly back towards the thumb but not nearer than 5cm/2in. from it. Frank Russell (see bibliography) calls this a brace cut.

(Below, left) *The rough out using the band saw, the blocks left on the nose and tail are removed using a hand saw.*
(Bottom) *Plywood rough out with waste indicated with diagonal lines.*

(Below, right) *Back view of the plywood tiger, position of legs marked out, waste indicated with cross-hatch lines.*
(Bottom) *Plywood rough out with waste from the leg area removed.*

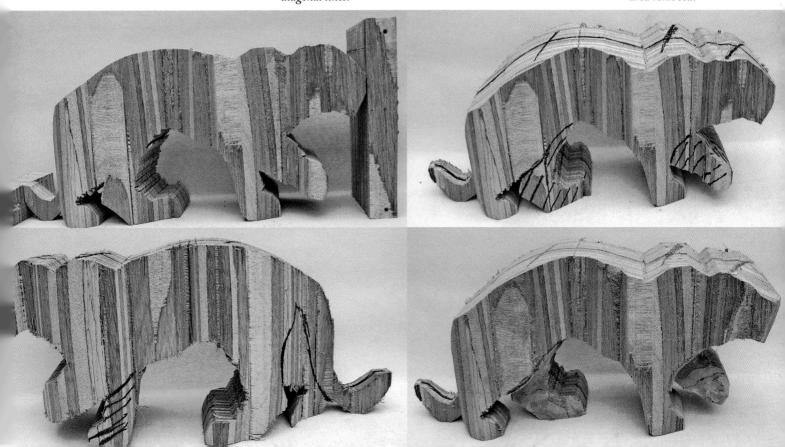

Shaping the rough outs

By referring to your model with its centre line and various datum points you can establish where you need to remove wood. Clearly mark areas to be removed with a pen, and remember if the centre line or significant datum point is removed during sculpting you should draw it back on as quickly as you can. In the beginning stages of shaping it is a process of rounding off the 'corners' left from creating the rough out stage.

Use gouges to shape the pine tiger, starting with a gouge (1.2cm/cut #5) or similar, gradually rounding off the shapes, always measuring, marking and chiselling with the model to guide you. (See chapter 5 for tips on using carving chisels.)

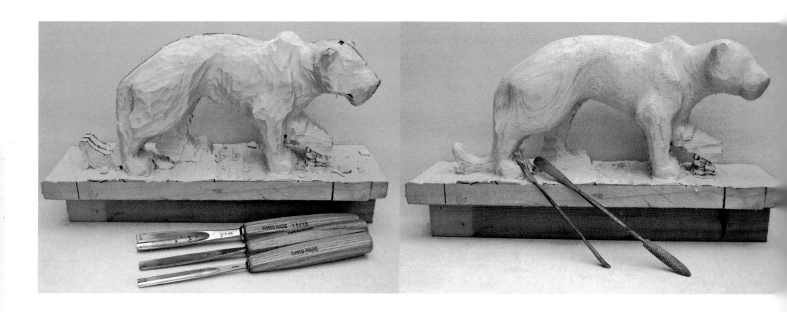

Shaping the pine tiger with a selection of chisels.

Pine tiger at the stage when chiselling is finished and the forms are refined with a coarse and then a fine riffler.

It is not practical to hold the work in a vice all the time, so once you feel that you have acquired the feel of the cutter, and as long as you keep the holding hand clear of the burr then it is safe to hand hold the work.

Just a word about dust. I use a good quality disposable dust mask and have a portable dust extractor on the bench as close as possible to where I am working. By using the reverse rotation setting on the Foredom flexible shaft tool, the burr throws the dust back towards the extractor and not into my face. Remove the marked waste as far as the centre line in order to be able to shape the outsides of the legs. Shaping inside and between the legs is only done after the outside shapes are clearly established.

Shaping the rough outs

By referring to your model with its centre line and various datum points you can establish where you need to remove wood. Clearly mark areas to be removed with a pen, and remember if the centre line or significant datum point is removed during sculpting you should draw it back on as quickly as you can. In the beginning stages of shaping it is a process of rounding off the 'corners' left from creating the rough out stage.

Using a coarse burr, (I find the 120mm (¾in.) ball nose shape very effective) stroke away the waste using the brace cut technique. Compare the shape you are forming with your model; use your callipers to check measurements.

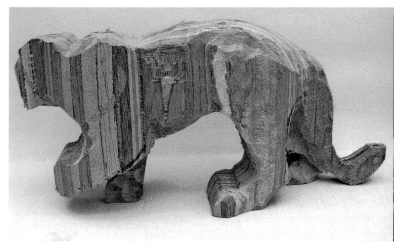

Plywood tiger showing legs roughed out with the flexible shaft machine using a coarse cutter. Notice that the insides of the legs have not been cut until the outside shapes are established.

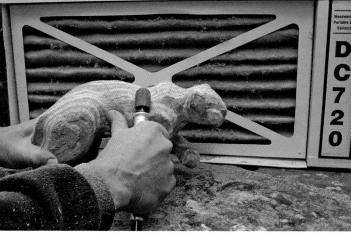

Photo showing hand position used when making 'brace cuts'. Notice the portable extraction unit close behind the sculpture. I wear a dust mask as well when doing very dusty work.

PINE TIGER – USING CHISELS, RASPS AND RIFFLERS

As the form becomes more refined you will need to take off smaller chips of wood; use a cut # 3, 8mm or cut # 5, 10mm for this finer work. It is important at this stage of the sculpture that you only work on the outside of the legs. The temptation is to round them off on the inside, but until the outside shape is absolutely established it is wise to leave that stage until later. When you are satisfied with the general shape of your sculpture then further refining of the shapes can be done using rifflers. You only need two, a fairly coarse 20cm (8in.) version for removing the tool marks and a fine 15cm (6in.) one to remove the rough surface made by the coarse riffler. Try to work with the grain as much as you can.

To create a smooth surface use abrasive papers; start with 60g followed by 100g when all dents and blemishes have been removed, soak the wood and leave it overnight to dry. Next day sand with 100g followed by 150g abrasive; soak and leave overnight to dry again.

Once the outer shape of the tiger is looking good, remove the waste wood from between the legs and by the tail using chisels, rifflers and finally abrasive papers. For removing wood from really fiddly places such as under the tail and on the insides of the feet use a smaller chisel such as cut #3, 3mm or 5mm wide.

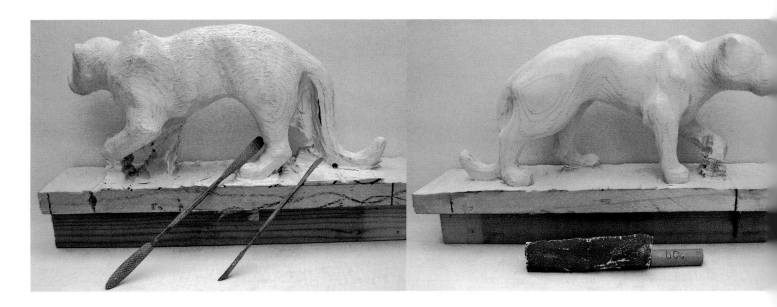

PLYWOOD TIGER – USING POWER TOOLS

Work over the entire wood surface removing small amounts e.g. 0.3cm (⅛in.) layers at a time. Try not to get too focused on just one area; ideally the whole sculpture should be at the same stage at any time. At this stage just work on the body and only the outside of the legs, leaving the removal of the waste from between the legs until you are satisfied with the outside leg shapes; if you have some spare wood you can still make adjustments if you need to. Use the burrs to remove the wood from between the legs, around the tail and shape the head.

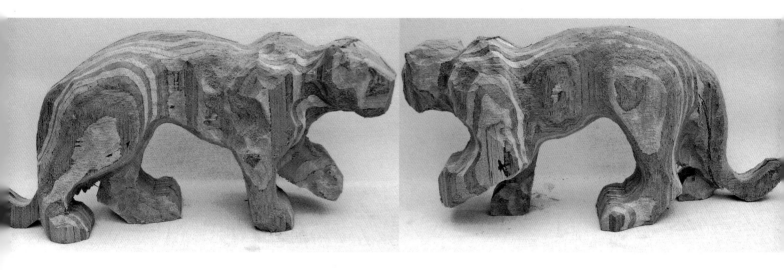

Plywood tiger roughed out upto the stage where finer burrs are used to refine the shapes.

Reverse side of plywood tiger.

PINE TIGER – USING CHISELS, RASPS AND RIFFLERS

Notice that the small bridge of wood (coloured blue) that supports the raised paw is still in place at this stage. This is to support the leg for as long as possible right up to the final sanding stages. After sanding between the legs with 60g and 100g abrasive paper wet the work and leave it to dry overnight to restore the crushed wood fibres. Sand and soak again as you think necessary. Finally shape the base, removing the bridge supporting the paw, using whichever tools you find appropriate and then lightly sand the surface with 150g paper, so that the tool marks create a planished surface (similar to beaten metal).

Finally sand the whole surface with 150g followed with 220g abrasive paper. Harder timbers may need finer papers to achieve a silky smooth surface. When you are satisfied with the surface it is time to finish the piece.

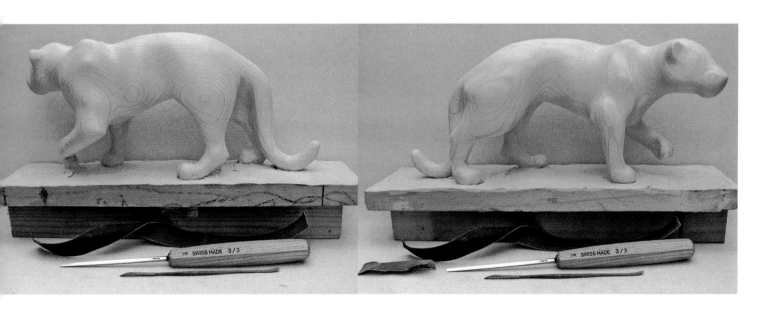

Reverse side of the tiger showing details.

The pine tiger showing the surface part sanded with 60g paper. Wrapping the abrasive around a piece of dowel helps to get on awkward places.

Continue measuring, marking and shaping, to gradually release the overall form. You should aim to reduce the form so that it is about 1mm (½2in.) larger than the model, the difference will be removed during sanding later. The photo on p. 111 shows the initial shaping stage at the point where finer burrs are needed.

Further refining of the shapes, softening the hills and valleys of the main shape is done with fine extreme Kutzall burrs, the 103mm (½in.) ball and 200mm (¾in.) ball nose shapes are most useful.

Although the flexible shaft burrs and abrasive fittings do produce a good surface it still needs to be softened and the shapes blended together and here hand sanding is most effective. Start with 60g abrasive paper and when you have smoothed out the rough spots, use a 100g abrasive making sure that all imperfections on the surface have been smoothed out. Because the surface of the plywood has been subjected to heat and pressure from the action of the abrasives and burrs, the surface fibres will have been compressed, so at this point soak the work and leave it overnight to dry thoroughly. It is always surprising how rough the surface is after the fibres of the wood are restored by this technique. Any very bad areas will have to be resanded with 60g paper and then resand the entire surface with 100g abrasive. When you feel that the surface is free of blemishes use 150g paper to further improve the finish. Narrow (2.5cm/1in.) cloth-backed abrasive belts are very useful for sanding in all the awkward places such as in-between the legs; 80g and 150g are very versatile papers.

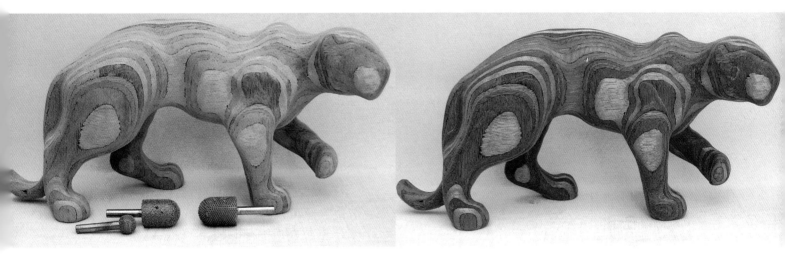

The surface after fine burrs have been used to refine and soften the overall shapes. The burrs shown centre and left are fine carbide Kutzall and on the right a coarse ball nose kutzall.

The plywood tiger has been sanded and then given a coat of sanding sealer to stabilise the surface of the wood to allow for finer sanding.

PINE TIGER – USING CHISELS, RASPS AND RIFFLERS

Finishing

Apply two or three coats of Danish oil with a clean cloth, kitchen paper or a new brush (keep it tightly sealed in a plastic bag between coats). Grey the surface with fine steel wool between coats. The final coat can be left as it is or gently grey the surface with fine steel wool and then apply a coat of good quality furniture polish.

Presentation and mounting

The base for this sculpture is part of the piece. How you shape it is a matter of personal choice. I shaped the base to give the impression of the shadow the animal might cast. The surface of the base has the tool marks still showing to give the feeling of a leafy surface and to act as a foil to the smooth surface of the tiger.

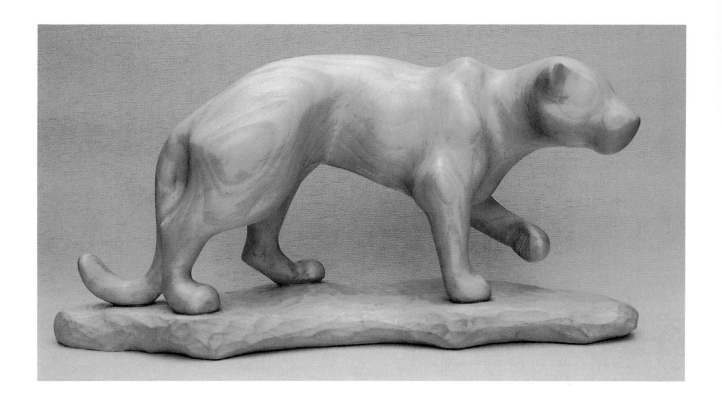

The finished pine tiger, the last coat of Danish oil left as applied.

Because plywood has grain layers running at right angles it sometimes tends to tear out as you work and so to stabilise the surface apply a coat of sanding sealer and let it dry thoroughly; sand again with 150g and then 220g by which time the surface should be smooth, and the tiger is ready for finishing.

Finishing

Use two coats of French polish to seal the grain; with both end and side grain present this gives a more even surface. Apply the polish with a new brush or clean white cloth. After it is dry, gently grey the surface with fine steel wool and apply a coat of good quality furniture wax.

Presentation and mounting

The plywood creates strong colours and patterns so I tried to use a base that would not clash with those effects. Plain and simple seemed best so I decided to use a piece of acrylic block. The juxtaposition of an animal species whose very existence is threatened by man and modern technology is symbolised by the natural wood of the sculpture and the plastic of the base.

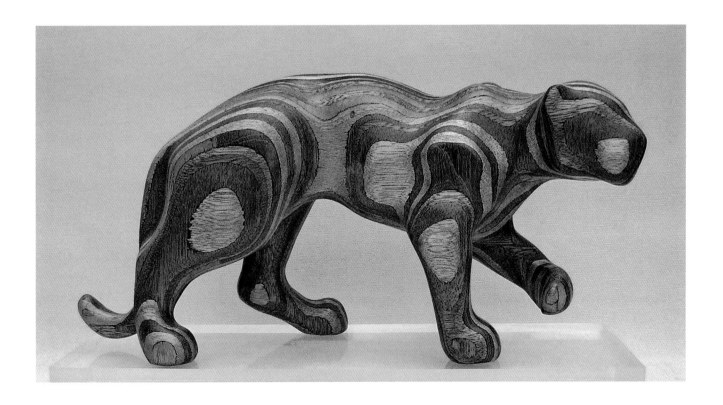

The plywood tiger with a final coat of wax polish mounted on a Perspex base.

GALLERY

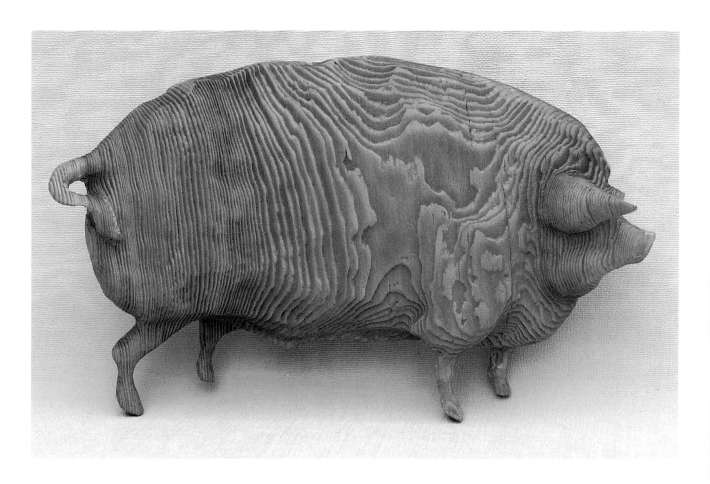

(Above) **Orchard Pig,** *by Peter Clothier. Pine, sandblasted, Danish oil finish.*

(Opposite) **Family Profile,** *by Paul Baden, 2006. Made from exterior plywood recycled from a skip, dimensions: 33.5 x 14 x 5cm (13¼ x 5½ x 2in.). 'Family Profile combines the features from four different members of a family, taking the most interesting element from each. Before I begin a large piece I make a smaller version in balsa wood first. This enables me to check whether the form will work in three dimensions and resolve problematic areas before using plywood. The tools I used for this piece were: jigsaw, angle grinder with flap disks, Dremel hobby tool, rasp, chisels, gouges, Stanley knife, lots of sandpaper and slip stones (plywood blunts sharp tools very quickly). I was hooked the first time I ever used plywood. I was a cartographic draftsman for over 20 years and fell in love with the way that the uniform layers in plywood mimic the contours found on maps.'* Photo by Paul Baden.

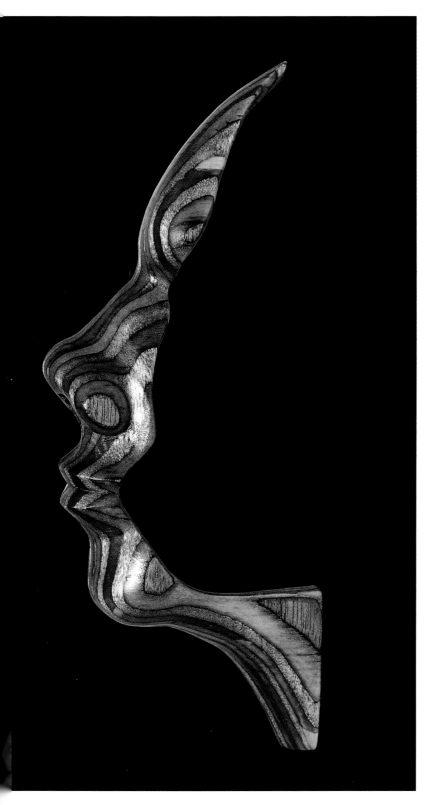

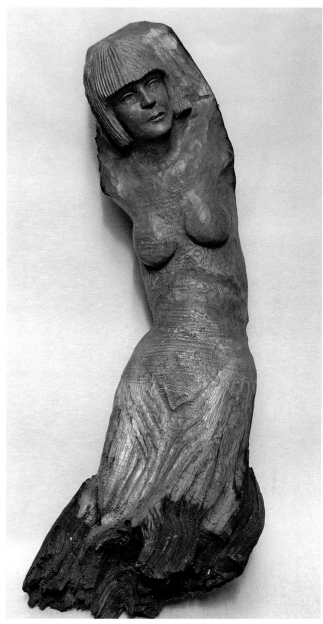

(Above) *Reclining woman by Peter Clothier.*

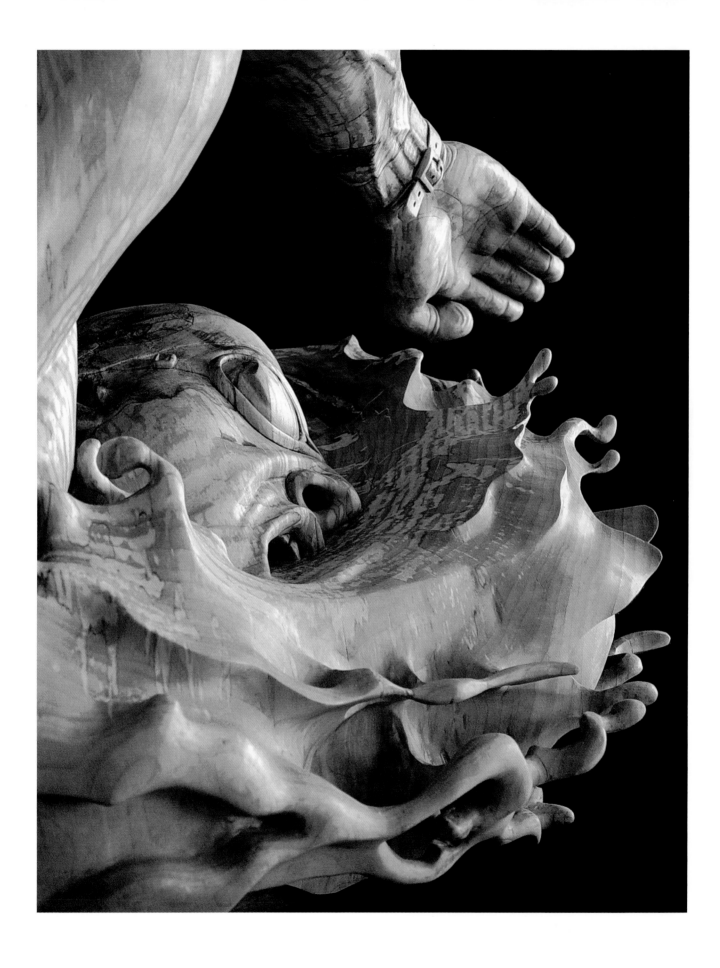

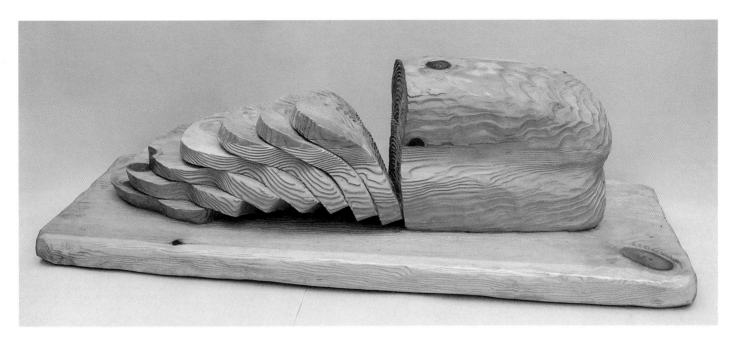

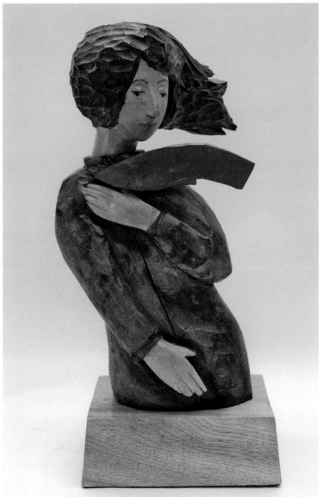

(Above) **Beachcomber's Bread,** *by Peter Clothier.*

(Left) **Braving the Storm** *by John Butler. This sculpture was started off by drawing in a sketchbook, and was then drawn onto limewood. The profile and outline were cut out by bandsaw. The form and outlines were then carved with a variety of gouges. It was painted with washes of diluted acrylic paint and varnished with silk finish varnish. 'This woodcarving is based on my daughter. She had been going through a difficult time and this was my way of expressing*
solidarity with her."

(Opposite page) **The Swimmer,** *by Steff Rocknack, 2006. Part of a three-piece commission called 'The Thriathlete', all life-size figures made from basswood. 'I began this piece with a chainsaw to make the rough cuts, and then used chisels to carve out the basic form. The surface has been painstakingly finished with 2000 grit sandpaper and tung oil – no tool marks remain. I currently work this way to give the surface of the wood a certain translucent depth, similar to what you might see on a fine piece of furniture. I do this because I am fascinated by the natural pattern of the grain, down to the smallest detail, the tiniest twist and turn, particularly in regard to how it reflects and enhances the overall mood of the piece.'* Photo by Steff Rocknack.

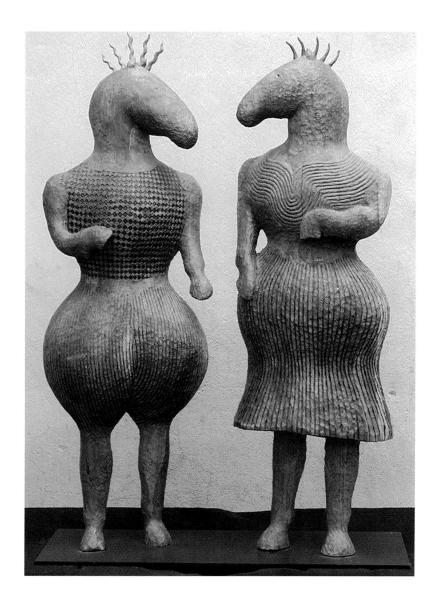

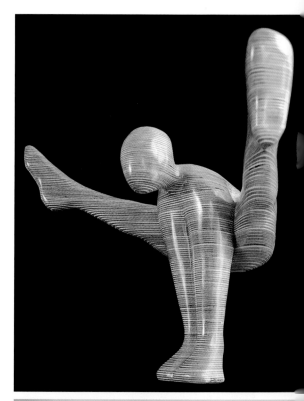

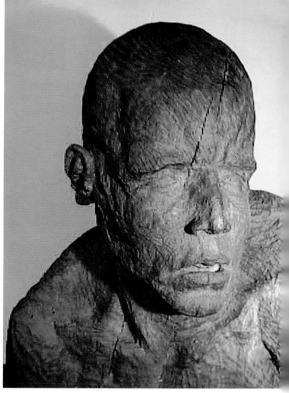

(Above) **King and Queen** *by Susanna Bergtold. 'I look for ways of taking an expressive or automatic gesture and trying to deepen it by a self-conscious technical approach.'* Photo by Susanna Bergtold.

(Above right) **The Leap** *by Paul Baden. Made from exterior plywood and finished with Ronseal varnish, dimensions: 50 x 50 x 27cm (19¾ x 19¾ x 10½in.). A smaller version was made in balsa wood before the commission was started properly in order to resolve problems. The tools used to make the piece were a jigsaw, angle grinder with flap disks, Dremel hobby tool, rasp, chisels, gouges, Stanley knife, sandpaper and slip stones (plywood blunts tools very quickly).* The Leap *was inspired while I was researching a Yoga sculpture I was commissioned to make ... I was fascinated by the harmonious balance and strength required in poses.'* Photo by Paul Baden.

(Right) **George**, *by Steff Rocknack.* Photo by Russ Rocknack.

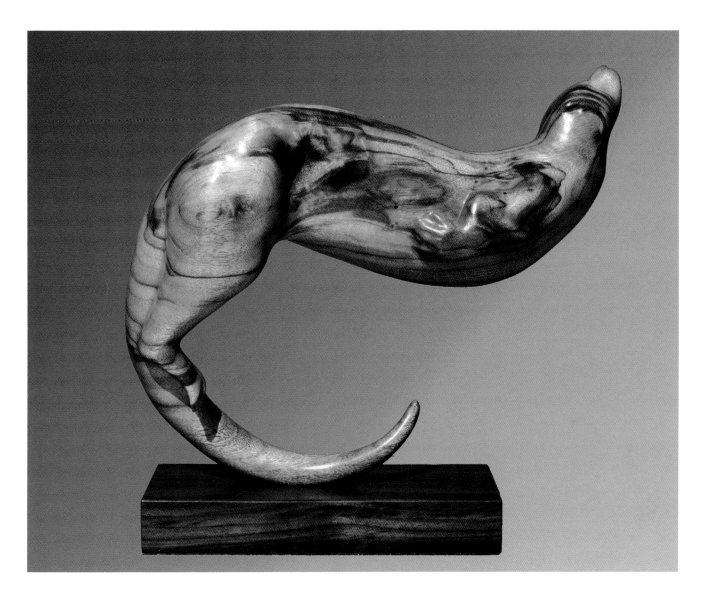

The Otter *by Bill Prickett.* 'The Otter *sculpture was a departure from my more usual detailed work and was inspired by a lengthy obser-
vation of a wild otter feeding off the west coast of Scotland. To try and capture the millifluous nature of the animal a more stylised
approach was taken with the design. As there was little detail to be carved in the piece it was an excellent opportunity to use a wood with a
strong grain pattern. I had a suitable sized piece of Camphor Laurel for the 10-inch long design, which fulfilled my requirements nicely.
My approach to woodcarving is always the same: constantly re-assessing the wood that needs to be removed and removing it. The otter was
carved with gouges and knife – I never use rasps or riflers as they bruise the wood and tear the fibres below the surface. The sculpture was
then sanded smooth and finished with a coat of finishing oil followed by a wax polish. It was mounted on a rosewood base.'*
Photo by Bill Prickett.

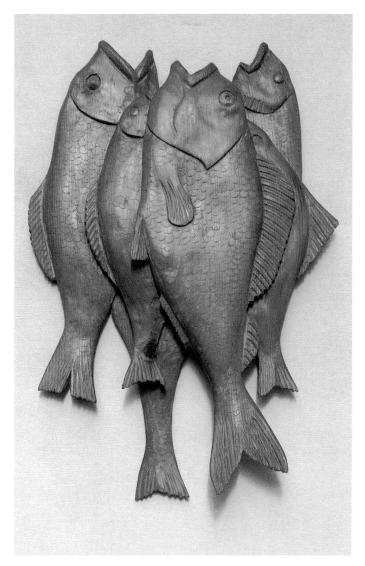

(Left) **Fish Choir** *by Peter Clothier. Lime wood, sanded finish decorated with gouge cuts, French polish and wax.*

(Right) **The Swimming Accident** *by John Butler. This sculpture was started off by drawing in a sketchbook, and then drawn onto lime-wood. The profile and outline were cut out by bandsaw. The form and outlines were then carved with a variety of gouges. It was painted with washes of diluted acrylic paint and varnished with silk finish varnish. 'I have always been interested in old photographs and bathing scenes. This woodcarving started off as a doodle based on a Victorian life guard who has had an unfortunate accident.'*
Photo by John Butler.

GLOSSARY

Abrasives – Grains of very hard materials applied to paper or cloth backings used in the final stage of smoothing a surface. The size of the particles is graded, the size is indicated by the letter P followed by a number (e.g.P120). The higher the P numbers the finer the abrasive.

Angle checker – A wedge shape cut at a specific angle from a flat piece of material. Home-made types can be made from card; brass units stamped with a range of angles are cheaply available.

Band sander – A machine, either portable or bench mounted, with cloth abrasive belts of varying widths and grits used to smooth surfaces.

Band saw – A piece of equipment that drives a continuous band of steel with saw teeth cut on one side. Because the bands are relatively narrow, curved cuts can be made, allowing complicated outlines to be quickly achieved.

Bench drill – A non-portable drill mounted on a shaft, giving the capacity to drill bulky objects.

Bench stone – The basic equipment for sharpening edge tools. They can be made from a huge variety of materials including natural stone, diamond, industrial carborundum and ceramic materials.

Bevel – Assuming a narrow, parallel thickness piece of steel. If you grind an angle on one face at the end, you have created a bevel. Basically that is a chisel.

Bow-legged callipers – Measuring instrument consisting of two legs of equal length, pivoted together. The legs are curved to allow measurements to be made around curved surfaces. Better quality types have a screw adjustment facility.

Callipers – *See bow legged callipers.*

Carver's chops – Wooden vice that has the advantage of very wide opening jaws.

Chisel – Hand tool consisting of a wooden handle fitted with a steel shaft of hardened steel to cut/chisel with.

Clamp/Cramp – Different spellings for the same tool. C or G shaped steel frame with one fixed pad and one adjustable pad, often on a screw thread, allowing the user to grip items of varying thicknesses.

Coping saw – Small saw with a U-shaped frame that has a very narrow blade allowing you to cut tight curves.

Danish oil – A proprietary oil specially formulated to be used for wood finishing.

Datum point – A fixed point that measurements can be made from.

Depth saw cuts – Cuts made to mark a place that will be more difficult to access when adjacent material is removed.

Dry wood – Timber cut to a specified thickness and the moisture dried by natural evaporation, either by air or natural seasoning, or dried by an industrial process using a special kiln.

Face side and face edge marks – Faces with these marks indicate that they are flat and at right angles to one another.

File – Piece of hardened metal with teeth cut in rows onto the surface. The teeth can be fine to coarse cutting and the blade can be anything from square to round in section.

Flat bit – Type of drill that is a shaft with a sharp flattened end of a given width. Usually made from poor quality metal, they blunt quickly, and are only suitable for work where nails or stones may damage better quality drills.

Flexible drive tools – Tools held in a hand piece connected by a flexible shaft to a high speed motor.

French polish – Made from shellac dissolved in alcohol and used to seal wood, usually as a base for a wax polish finish.

French polishing – The very glossy surface achieved by applying many layers of polish with a special pad.

G-cramp/clamp – *See clamp.*

Gouge – Carving chisel that is deeply curved along the axis of its shaft. Those with slight curvature have a 'slow cut' or are called 'sweeps'. Small gouges are called veiners since they were used for cutting the veins on carved leaves.

Green wood – Timber that has been cut from a tree and is still full of sap. If it has been cut into boards in preparation for drying then it will be called unseasoned.

Greying – Gentle abrading of a surface with steel wool; usually between finishing coats or prior to applying wax polish.

Grinding – Removal of metal with a relatively coarse stone. Tempered tools such as chisels have to be kept cool during this process or the steel will soften, so a water-cooled whetstone must be used. Small amounts of grinding can be achieved on a coarse bench stone.

Grit – another name for the individual particles of abrasives.

Hard point saw – Made from very hard steel but after a lot of use they turn blunt – throw it away and buy a new one.

Hard woods – Technical classification based on the fact that the timber comes from a dicotyledonous (two seed leaves) tree.

Heart/heartwood – Timber from the centre of the tree trunk or branch, usually dead cells that supply the rigid support for the tree.

Heart (of the wood) – The middle of the concentric annual growth rings that can be seen in a cross section of a tree. (Quite often this is not in the middle because growing conditions often make trees grow unevenly.)

Honing – Final stage of sharpening an edge tool using a fine stone.

Included angle – Angle between two given straight lines.

Jig – Piece of equipment that holds a tool or materials in place in order to perform a specific action.

Jig saw – Powered hand tool that has a narrow reciprocating saw blade up to 7.5cm (3 in.), used for making straight or curved cuts in a variety of materials.

Mallet – A tool used for assisting the cut when chiselling.

Mandrel – A round shaft that is held in a chuck with a threaded end onto which various fittings can be attached.

Maquette – The French word for a scale model, used by sculptors. This is a small preliminary model made from clay, wax or plasticine.

MDF – Medium density fibre board; sheet material manufactured from wood fibres and glue. Very useful but any dust generated during use must be removed by extraction.

Microplanes – Basically a fine wood grater, this is a very useful tool for removing waste timber.

Nibs – Small particles of dust and wood fibres that are trapped in the final finishing coats causing rough places on the surface. Usually removed with fine wire wool.

Pillar drill – Same as a bench drill, differing in that they are floor standing with a consequently longer shaft.

Planished – Having a surface that is similar in texture to beaten metal.

Power drill – Drilling tools powered usually by an electric motor, which can be mains or battery powered. Small ones are hand held; larger ones are bench mounted (see bench drill).

Power sanding – The process of sanding when performed with one of the many sanding tools available.

Rasp – Made from hardened steel with individual teeth cut along the blade. The meaning has been extended to mean tools that consist of a shaft coated with abrasive materials such as carbide granules or diamond dust.

Rifflers – Steel tools usually consisting of a slim handle with a spatulate or rat-tail shaped blade on each end. These ends can be patterned as files (usually for metalwork) or rasps for wood. The new generation of rifflers have diamond coated blades.

Rotary tools – A huge range of tool bits that can deal with any sculptural situation. They are either fitted to flexible drive tools or multi tools (drill/grinders).

Rough out – A piece of wood that has one or more profiles shaped on it.

Roughing out – The removal of the bulk of the waste wood on a sculpture usually by sawing.

Sanding sealer – White French polish that has a filling agent used to stabilise and fill the pores of a surface during final sanding.

Sanding sticks/boards – Homemade finishing tools made by gluing abrasive paper to boards or shaped sticks in order to access awkward places on a sculpture.

Sapwood – The wood that surrounds the heart wood. These are living cells involved in the growing of the tree.

Seasoned wood – *See dry wood.*

Slash gloves – These protect your hand from cuts when using carving knives and aggressive rotary cutters.

Slip stones – Wedge shaped sharpening stones; the thick and thin edges are radiused so that they can fit inside the channel of woodcarving gouges.

Soft woods – timber that comes from cone bearing trees (monocotyledons). Some are harder than so called hard wood species.

Stock removal – Removal of a bulk of unwanted wood, usually by sawing.

Strop – A piece of leather dressed on the suede side with a fine cutting compound that is used to maintain the edge on cutting tools.

Surform – This very useful hand tool is in effect a heavy duty wood grater used for fast removal of waste wood. Various shaped blades; the tube shaped one is the most useful.

Swing brace – An old fashioned tool that uses twist bits, very handy for drilling large holes where there is no power source.

Template – A pattern usually made from paper or thin plywood used for marking out the profile of an elevation.

True [as in true-up to an edge] – The removal of waste wood back to a marked line.

Try square – this is a precision tool, L-shaped, with a blade (not sharp) held at an exact right angle to a thicker stock. It is used for marking out and checking for right angles.

Unseasoned wood – *See green wood.*

Warp – Twisting in timber caused by the effects of drying out.

Washita stones – Much prized natural stone used for fine honing of chisels.

Waste wood – Any wood not needed for a job; usually indicated by parallel diagonal pencil lines.

Wheel brace – Hand drill that is driven by turning a handle fixed to a toothed wheel which turns a smaller wheel thus rotating the chuck held drill.

Whet stone – Traditional round water cooled sharpening stone, hand or machine powered, used for grinding edge tools.

Wire wool – Finely shredded steel that is used to abrade surfaces.

LIST OF SUPPLIERS

Because I work in the U.K., I use tool and wood suppliers here. I suggest that you search for your requirements in the Woodcarving magazine and other woodworking publications in your area. Telephone directories are the obvious source of local tool suppliers but more especially wood sources such as timber sawyers and yards, timber importers, tree surgeons and recycling centres.

U.K. Suppliers
* means this company also sells timber

*Axminster Power Tool Centre,
Chard Street, Axminster, Devon,
EW13 5DZ
www.axminster.co.uk.
Excellent mail order department selling everything

Robert Bosch Plc.,
Box 98, Broadwater Park, Denham,
Uxbridge, Middlesex, UB9 5HJ
Tel. 01895 838 383
Portable tools, Dremel multi-tools

Black and Decker
210, Bath Road, Slough, Berkshire, SL1 3YD,
Tel. 01753 511 234
Huge range of power tools

Carroll Tools Ltd.,
16-18, Factory Lane, Croydon,
Surrey, CR0 3RL.
Tel. 0181 781 1268
Sanding supplies

*Craft Supplies Ltd,
The Mill, Millers Dale, Buxton,
Derbyshire, SK17 8SN.
www. craft-supplies.co.uk.
Good mail order dept; large range of tools and exotic timber

English Abrasives Ltd.,
PO Box 85, Marsh Lane, London, N17 OXA
Tel. 0181 808 4545
All types of abrasives

Hegner U.K.
Unit 8, North Crescent, Diplocks Way,
Hailsham, East Sussex. BN27 3JF
Tel. 01323 442 440
Saws and flexible drive tools

Liberon
New Romney, Kent, TN28 8XU
Tel. 01797 367 555
Polishes, oils and every thing you need for finishing

*Pintail Carving
20, Sheppenhall Grove, Aston,
Nantwich,
Cheshire, CW5 8DF.
Tel. 01270 780 056
Very helpful with advice on flexible drive tools, including Foredom, Karbide Kutzall burrs, carving Discs. Excellent mail order

*Timberline,
Unit 7, Munday Industrial Estate,
58 – 66, Morley Road, Tonbridge,
Kent. TN9 1RP
Tel. 01732 355626
www.exotichardwoods.co.uk
Lots of amazing timber

Rod Naylor
Turnpike House, 208, Devizes Road,
Hilpererton, Trowbridge, Wilts.,
BA14 7OP.
Tel. 01225 754 497
Flexible drive tooling; Tornado cutters

Yandle & Sons.
Hurst Works, Martlock,
Somerset TA12 6JU
Tel. 01935 822207
Timber and tools

Europe
Pfeil,
www.pfeiltools.ch
E-mail info@pfeiltools.ch
Swiss carving tools and equipment

Dick GmbH
Donaustr.51
94526 Metten
Germany
Catalogue of hand tools to covet! Books too and they do an English version of their catalogue

U.S.A. Suppliers

Airstream Dust Helmets
P.O. Box 975, Elbow Lake,
MN56531,USA
Tel. 800 328 1792
Dust protection

*Craftwoods
PO Box 527, Timonium,
MD 21094-0527, USA
Tel.800 468 7070
Flexible drive tools and fittings

Dremel
PO Box 1468, Racine,
WI 1 653401-1468, USA
Tel. 800 437 3635
Flexible drive tools

The Foredom Electric Company,
16 Stoney Hill Road, Bethel, CT 06801
USA
Tel. 203 792 8622
Tools and fittings for flexible drive tools

Pfingst & Co Inc.
105 Snyder Road, PO Box 377, South
Plainfield, NJ 07080
Tel. 908 561 6400
Flexible drive machines

*Timbercrafts
Rt 214, Lanesville, NY 1245, USA
Tel. 914 688 7877
Carving supplies

Owl by Peter Clothier.

BIBLIOGRAPHY

Duginske, Mark, *Bandsaw Handbook*, Sterling, 1990

Russell, Frank C., *Carving Realistic Animals With Power*, Schiffer Books, 1994

Kingshott, Jim, *Sharpening: The Complete Guide*, GMC Publications, 1998

Plowman, John, *The Sculptor's Bible*, A&C Black, 2005

Cartmell, Ronald, *Wood Sculpture*, Allman and Sons, 1970

Herder, K.G., *Carving Wooden Animals*, Search Press, 1971

Pye, Chris, *Woodcarving Tools and Equipment*, Vol. 1, GMC Publications, 2002

Muybridge, Eadward, *Horses and Animals in Motion*, Dover, 1986

Blaxendall, Michael, *Limewood Sculptors of Renaissance Germany*, Yale, 1995

Tippey, David, *Power Tools for Woodcarving*, GMC Publications, 1999

Mills, John W., *The Technique of Sculpture, Batsford*, 1965

Simpson, Ian, *The Encyclopedia of Drawing Techniques*, Quarto Publishing, 1987

Wardell, Sasha, *Mould Making*, A & C Black, 1997

Periodicals

Woodcarving Magazine, bi-monthly.

Tel: 01273 477374

E-mail tony@thegmcgroup.com

Websites of Artists represented

Peter Clothier www.peterclothiersculpture.co.uk

Steff Rocknak www.steffrocknak@yahoo.com

Susanna Bergtold www.susannabergtold.com

Mick Burns www.chainsawsculpture.co.uk

John Butler R.W.A. www.johnbutlerwoodcarver.co.uk

Paul Baden www.paulbaden.co.uk

Heather Jansch www.jansch.freeserve.co.uk

Bill Prickett www.billprickett.co.uk

INDEX